POSTCARD HISTORY SERIES

Rockford

1920 and Beyond

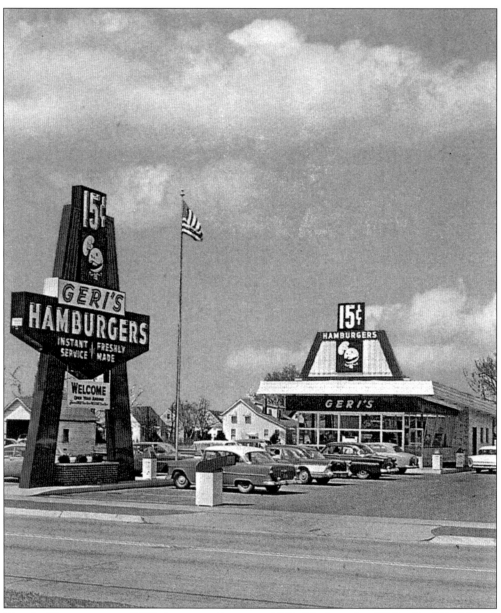

GERI'S HAMBURGERS, 2521 AUBURN STREET, 1963. During the 1960s, Rockford-based Geri's (1962–81) successfully tapped into the nation's drive-in crazed car culture, competing in a crowded local market that included national chain A&W, Champaign-based regional Dog 'n Suds, and homegrown ventures including Skeet's, Top Hat, Top Boy, the enduring Zammuto's and c. 1952 Bing's, H. John Carbaugh's "Beaky's" (1965–80), and Joseph Engebretson's popular Hollywood (1952–93), Rockford's undisputed drive-in king. At its height in the late 1960s and early 1970s, Geri's boasted thirteen outlets—seven in Rockford, in addition to regional state line drive-ins at Freeport, Galena, Janesville, and Beloit, where an independently-owned Geri's still endures. This coupon postcard offered its bearer a complimentary "delicious 3-course meal consisting of a tasty 100% pure beef U.S. Gov't. inspected hamburger, luscious golden french fries and a noticeably richer milk shake."

POSTCARD HISTORY SERIES

Rockford

1920 and Beyond

Eric A. Johnson

ARCADIA

Published by Arcadia Publishing,
Charleston SC, Chicago IL, Portsmouth NH, San Francisco CA

Printed in Great Britain.

Library of Congress Catalog Card Number: 2004106244

For all general information contact Arcadia Publishing at:
Telephone 843-853-2070
Fax 843-853-0044
E-Mail sales@arcadiapublishing.com
For customer service and orders:
Toll-Free 1-888-313-2665

Visit us on the internet at http://www.arcadiapublishing.com

This book is dedicated to my wife Barbara, daughter Evelyn and son Andrew, in grateful appreciation for their love and support. This book is also dedicated in loving memory of my firstborn infant son, Samuel Christopher Johnson.

(Front Cover) **STATE STREET LOOKING WEST TOWARD WYMAN STREET, 1928.** Rockford's downtown Loop was a thriving commercial center in the "Roaring '20s." Dominating the skyline are Rockford National Bank's 11-story Trust Building (left) and the 13-story *c.* 1927 Talcott Building (right). Retailers at left include King Jo Lo Chop House, the enduring Anger's Jewelers, and the Dreamland Theater, opened in 1908. At right is the flagship department store of Rockford-based Charles V. Weise Co. (now Bergner's) and A. Emmett and John W. Hickey's popular Hickey's Restaurant (1909–73). Both sides of the 100 block of West State at immediate left and right were razed in the 1970s for two major riverfront urban renewal developments—United Bank (National City) Plaza and the Luther Center senior high rise. Anger's, founded in Oskhosh, Wisconsin in 1886 and relocated to Rockford in 1913, operates today at Edgebrook Center, 1645 North Alpine.

(Back Cover) **WEST STATE STREET LOOKING EAST FROM CHURCH STREET, 1965.** Today a virtual ghost town after 5 p.m., downtown was alive with nighttime activity in 1965, when this postcard commemorated Rockford's new $250,000 downtown lighting system. While the new lights transformed Rockford's Loop into the "brightest downtown in the world," the renewal initiative failed to stem downtown's decline in the 1960s to early 1980s. Once Rockford's retailing center, every identifiable business pictured has either moved or closed. Casualties include Osco Drug (1951–83) in the Nu-State Building and Chicago-based Carson Pirie Scott & Company's department store (1927–70) in the Talcott Building. Founded in 1896, Bolender's Jewelers (far right) relocated to Brynwood Square, 2589 North Mulford, in 1979. (Photo: Henry Brueckner)

relocated to Cherryvale Mall then to Edgebrook closed - 2005/06 Christmas season

CONTENTS

ACKNOWLEDGMENTS

My 11-year creation of *Rockford: 1920 and Beyond*, like most worthwhile endeavors, was accomplished with the assistance and support of many individuals.

While my personal collection provided many of the postcards herein, I am extremely grateful to Rockford's Midway Village & Museum Center and avid Rockford postcard collectors Lewis Moore, Mary Lou Liebich Yankaitis, Mathew J. Spinello, and Mark D. Fry for generously opening their collections. My thanks also extend to Rod MacDonald, Tom Claybough, Nels Akerlund, Jon McGinty, Thomas Guschl, John Babcock, Bert E. Johnson, Bryn Carter, Dave Lombardo, Mrs. Roy L. Anderson, Eldon Glick, Dexter Press, and Graham-Ginestra House Inc. for their postcard contributions. A special thanks to Eldon Glick for use of the postcard images of longtime Rockford postcard photographer Henry Brueckner.

I am deeply indebted to Midway curator Rosalyn Robertson for coordinating the book's high-quality CD-ROM scans.

I offer my thanks to the following for their invaluable input: Jerry Baker and Rod MacDonald for their remembrances of WREX-TV's early years; Winona Kling and the North Suburban Library for information on Kiddieland Park; and Steve Clark for information on the 55-year auto retailing legacy of his father, D.M. "Swede" Clark.

I owe many thanks to John L. Molyneux, curator of the Rockford Public Library's downtown Local History Room, for reading my manuscript and making many valuable suggestions and corrections. I am also grateful for his gracious assistance guiding me through the library's extensive local history archives.

My appreciation also extends to the downtown reference desk librarians for their above-and-beyond accommodation of my voluminous requests for the library's "Rockfordiana" newspaper clipping archive.

I also owe many thanks to my friends-turned-family, Rockford residents Mike and Kay Douglas, for their warm and generous hospitality during my many research trips to Rockford. A special thanks to Kay, an award-winning longtime English instructor at Rockford's Jefferson and West High Schools, for her input on the evolving manuscript.

I'm deeply grateful for the assistance of my Arcadia editor, Elizabeth "Liz" Jobe. Taking over the reins of this project mid-stream, Liz oversaw the 2003 publication of *Rockford: 1900–World War I* and the entire creative effort behind *Rockford: 1920 and Beyond*.

My thanks also go to downtown businessmen Jerry Kortman and George "Doc" Slafkosky. As fellow Rockford historic preservationists and local history buffs, their longstanding enthusiasm for both books has been a steadfast source of inspiration and support.

But most of all, I offer my heartfelt thanks to my family—wife Barbara, daughter Evelyn, and son Andrew—for their loving support and understanding during my long preoccupation with researching and writing this book.

INTRODUCTION

"It [Rockford] is as nearly typical of the United States as any city can be."
-Life Magazine, September 1949

Thanks to *Life*'s mid-century popularity and prestige, Rockford would gain a solid reputation as the quintessential "Typical American City," a moniker that continues, by and large, to this day.

Indeed, this *1920 and Beyond* look at Rockford history largely mirrors the ebbs and flows of United States life during the bulk of the dynamic "American Century," a period marked by continual and ever-accelerating change.

Rockford's heady economic boom years in the inaugural decades of the 20th century, covered in *Rockford: 1900–World War I*, continued into the ebullient Roaring Twenties, as the city's newly-erected Talcott, Manufacturer's National Bank, Rockford News Tower, Gas & Electric, and Faust Hotel "skyscrapers" came to vividly symbolize Rockford's ambitious and courageous "sky's the limit" spirit.

But the good times came to a grinding halt with the arrival of the Great Depression, years marked by bank closures and business failures, soaring unemployment, tragic foreclosures, growing welfare rolls, and federally-sponsored brick-and-mortar Works Project Administration jobs aimed at reviving the moribund economy.

With its longstanding blue-collar industrial roots, Rockford enjoyed renewed and even greater prosperity as it readily capitalized on the World War II war effort and manufacturing's post-war economic boom years of the 1940s, 1950s, 1960s, and early 1970s—decades of unprecedented economic expansion and upward mobility that would grow Rockford into "Illinois' Second City."

But in contrast to the heady economic times of the post-World War II boom decades, Rockford's early 1980s "Second Depression" was a bleak economic period, as numerous industries closed or relocated, downtown withered, population declined, unemployment soared to a nation-leading 25 percent, and Rockford struggled to reinvent itself in a new era geared toward technology and global competition.

Improved economic times, coupled with visionary public and private leadership and economic development efforts, spurred Rockford's quiet but steady renaissance in the mid-to-late 1980s and 1990s as population grew, borders enlarged, and the local economy diversified, with Rockford garnering National Civic League "All America City" honors in 1992.

Today a recognized world leader in the production of machine tools, fasteners, and auto parts, Rockford is increasingly known as an important center for aerospace components. And from a large reliance on its longstanding historic manufacturing base, Rockford's economy has diversified into a broader set of enterprises, including a growing tourism industry, and a "new economy" distribution center, air cargo and call center/office operations. Downtown Rockford, meanwhile, has experienced a still-evolving renaissance as a center for specialty retailing, dining, entertainment, arts, and urban living.

But as the latest chapter of history waits to be written, Rockford faces a new test of its resiliency, as the local economy struggles with rising unemployment and factory downsizings and closures spurred by a number of factors including recession, global competition, bankruptcy, corporate relocation, outsourcing, increased outside ownership, and the export of jobs to low-wage countries.

Despite the tide of evolution and revolution presented by a dynamic century, postcards—from early chromolithographs and mid-century linens to modern chromes—have remained steadfast to their simple calling: silently but poignantly chronicling the people, places, institutions, and events that have shaped the history of "Remarkable Rockford."

As a former Rockfordian with an enduring love for the city, it's my hope that this book, and its *Rockford: 1900–World War I* predecessor, stir your interest in discovering Rockford's rich history.

In this, Rockford's 170th year, it is with great pleasure that I present this postcard-illustrated history of the "Forest City."

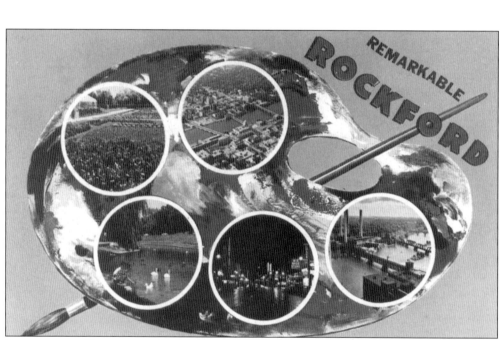

REMARKABLE ROCKFORD, 1964. After the lean and often-desperate Depression years, Rockford's hard-hit manufacturing-based economy revived with the World War II effort and the unprecedented post-war economic expansion of the late 1940s, 1950s, 1960s, and early 1970s, years when the nation's economic output and personal incomes soared. As Rockford's economy boomed, annexations, an influx of job-seeking new residents, and the post-war "Baby Boom" turned Rockford into Illinois's fastest-growing city. From a population of 92,927 in 1950, Rockford's 126,706 residents by the 1960 census grew the Forest City into "Illinois' Second City," a prestigious ranking held until 151,170-resident Rockford was surpassed by Aurora in 2003. (Courtesy: Dexter Press)

One

AROUND THE TOWN

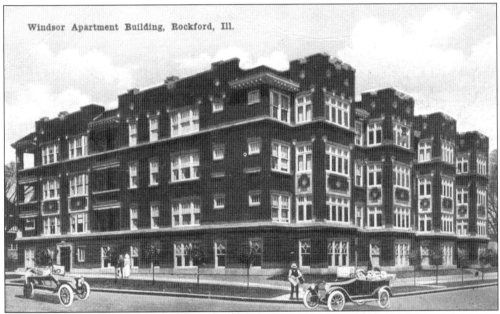

Windsor Apartment Building, Rockford, Ill.

WINDSOR APARTMENT BUILDING, 902-910 NORTH MAIN STREET, 1920. Anchoring the busy northwest corner of North Main and Whitman Streets since 1917, the 22-unit Windsor Apartments is one of Rockford's most recognizable residential properties. Built as a high-end luxury apartment development, the Windsor was designed by Rockford architect Frank Carpenter in a "Wrigleyville" architectural style, common around Chicago's Wrigley Field. Hearkening back to a classic American era of luxury and opulence, the Windsor's 6- and 7-room apartments offer architectural amenities including built-in china cabinets and bookcases, hardwood flooring, high ornate ceilings, butler's pantries, and oak-mantled fireplaces. After declining in stature and maintenance over several decades under a number of owners, the Windsor was sold to Rockford developer William Charles Ltd., which undertook an extensive renovation in 1996–97, refreshing the grand dame property to its original character. Barrington-based Terrace Realty bought the Windsor in 2003.

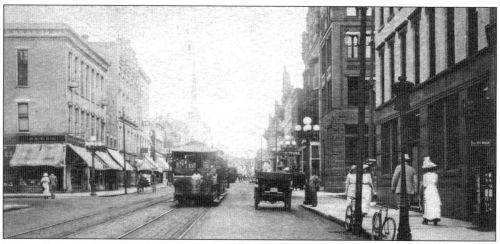

STATE STREET, EAST OF FIRST STREET, 1920. Downtown Rockford's east-side commercial district was bustling with activity shortly after World War I. Surviving structures at left include, (from left) the old Keeling Bros. Drugs Building, the *c.* 1862 limestone Beale Building, the high-rise *c.* 1856 Metropolitan Block, and several restored structures spanning 416-424 East State—the *c.* 1907 F.S. Datin Block, the *c.* 1879 Nash Block, and the Superior Block. Demolished at right are Manufacturer's National Bank (far right), 327-29 East State, the *c.* 1884 Third National Bank Building, 401 East State, and the *c.* 1889 George M. Blake Block, 403-05 East State. Third National (Bank One Rockford), founded in 1854 and renamed First National in 1958, razed the Third National and Blake Blocks for a $2 million *c.* 1968 high-rise banking center. A $1 million 1982 East State streetscaping project spurred private redevelopment of downtown's east side.

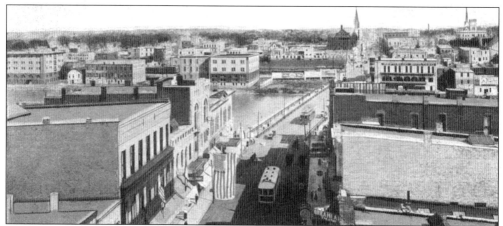

HEART OF BUSINESS DISTRICT, 1920. Rockford's low-rise, post-World War I east-side downtown skyline (top) would take on a vibrant, big-city look during the Roaring Twenties, as downtown Rockford touched the sky with its cosmopolitan steel-and-stone towers. Major legacy "skyscraper" additions to the east-side skyline along East State Street would include the eight-story Classical Revival-styled Manufacturer's National Bank Building in 1926, the eleven-story Art Deco Hotel Faust in 1928–30, and Rockford Consolidated Newspapers' eight-story Art Deco-styled riverfront Rockford News Tower in 1928–32. A time of great growth, Rockford's population more than doubled from 31,051 in 1900 to 65,651 in 1920, and soared to 85,864 by 1930.

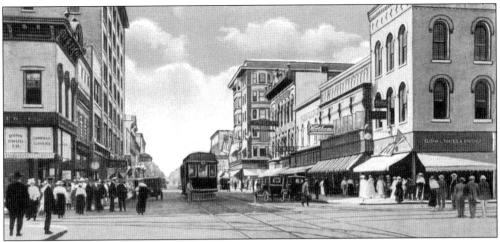

"TRANSFER CORNER," 1920. At its height, the Rockford & Interurban Railway Company's busy West State and Wyman transfer corner served 800 streetcars daily, making it a natural retail center in downtown's popular Loop business district. Transfer Corner anchors included Dunn Drug Co. at 202 West State and Elisha L. Thayer & Brother Co. at 201 West State, a jewelry and optical business established by Elisha and Frank T. Thayer in 1896. Dominating the west-side skyline at left is Rockford National Bank's seven-story Trust Building. At right, other West State retailers include leading women's clothing couturier Horace L. Wortham, A.C. Deming Dry Goods & Millinery, C.F. Henry Clothing Co., and Ashton's Dry Goods Co., a city retailing institution under the Ashton, Rockford Dry Goods, and Rockford Store banners from 1878–1974.

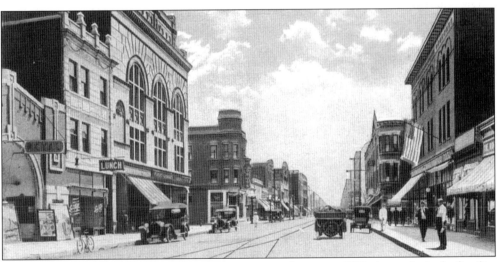

SEVENTH STREET LOOKING SOUTH FROM THIRD AVENUE, 1920. An enduringly familiar view, Seventh Street survivors include the *c.* 1910 Lagerquist Building, second from left at 324 Seventh Street; the tower-clad People's Pharmacy Building across Third Avenue, 402 Seventh Street (left center); and the three-story Skandia Hardware Co. Building at right, 325-29 Seventh Street. Today just a fond memory is the *c.* 1915 Royal Theater, at 322 Seventh Street, built by prolific Rockford architects Peterson & Johnson and operated under the Royal, Strand, Roxy, and Rex marquees into the 1940s. Also missing is the National Register-listed *c.* 1893 Svea Soner Music Hall, third from left at 326-30 Seventh Street, the victim of a 1980 blaze.

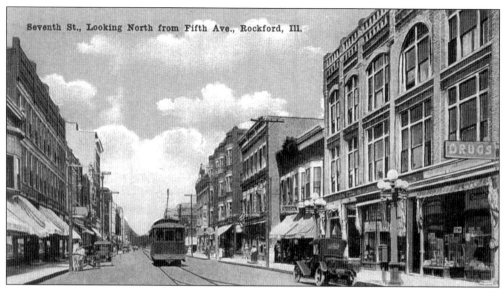

SEVENTH STREET LOOKING NORTH FROM FIFTH AVENUE (RAOUL WALLENBERG WAY).
While the east (right) side of Seventh Street between Fifth and Fourth Avenues remains a familiar sight, the west side has radically changed since the 1920s. Working to revitalize Rockford's declining ethnic Swedish commercial district in the early 1980s, longtime Seventh Street anchor AmCore Bank (*c.* 1910) undertook a major urban renewal initiative of the 500 block at left with its high-rise AmCore Financial Plaza, at 501 Seventh Street. Familiar sights at right include the Gorham Building, the Furniture Block, and the National Building (far right). (Courtesy: Mark D. Fry)

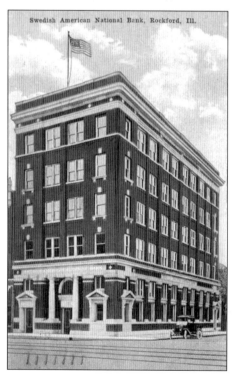

SWEDISH AMERICAN NATIONAL BANK, 501 SEVENTH STREET, 1921. Established in 1910, Rockford's Swedish American National Bank retained leading city architects Edward A. Peterson and Gilbert A. Johnson to design this *c.* 1915–16 high-rise bank headquarters. One of the few Rockford banks to survive the Great Depression, Swedish American has operated under several names since 1945—American National Bank & Trust, Illinois National Bank & Trust, and today's AmCore Bank. Spearheading a private revitalization initiative in Rockford's declining Seventh Street commercial district, the bank acquired and razed its block, bordered by Fourth and Fifth Avenues and Sixth and Seventh Streets, erecting its $11.3 million, seven-story AmCore Financial Plaza in 1982–83.

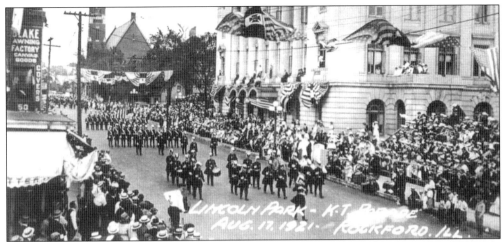

KNIGHTS TEMPLAR PARADE, AUGUST 17, 1921. The highlight of Rockford's two day statewide Knights Templar convention was this "stupendous" downtown parade, featuring 85 Illinois commanderies. The two hour Masonic parade, which drew tens of thousands of spectators, was billed by the Rockford *Republic* as "the largest ever undertaken in Rockford." Heading east on Elm Street, near the flag-draped Winnebago County Courthouse Annex, is the Lincoln Park Knights Templar Commandery Band, escorts to Illinois' Right Eminent Grand Commander, Major Roland M. Hollock. (Courtesy: Mark D. Fry)

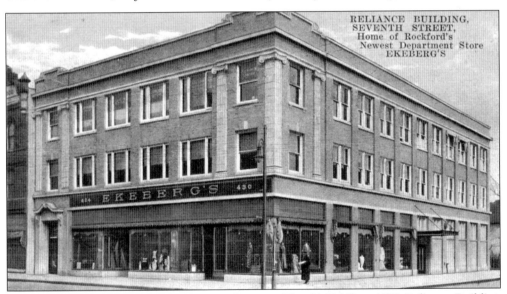

RELIANCE BUILDING, 422-30 SEVENTH STREET. The $168,000 *c.* 1923 Reliance Building remains a familiar sight on the northeast corner of Seventh Street and Fourth Avenue. Anchored by Rockford-based Ekeberg's Dry Goods (1908–58) from 1923–28, the Reliance Building is today owned by Rockford-based AmCore Bank as its "Plaza Seven" office building. Originally an unassuming residential street, commercial development of Seventh Street began in 1884 and took over the street by 1889 as "block after block sprang up like magic...transforming the once quiet street into a thoroughfare of consequence." Development continued until the Depression, with many of Seventh Street's enduring commercial buildings built between 1900–1930.

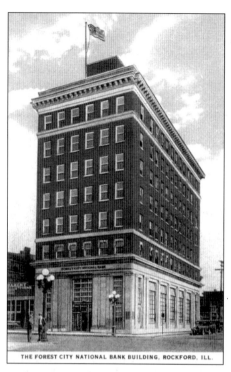

THE FOREST CITY NATIONAL BANK BUILDING, ROCKFORD, ILL.

FOREST CITY NATIONAL BANK, 401 WEST STATE STREET. In 1923, Forest City National Bank (1890–1932) moved from its longtime home in the nearby Sumner Building, at 328-30 West State, to its newly-built, eight-story Forest City National Bank Building—today's Enterprise Building. Following Forest City's Depression-era demise, this structure would revive as a longtime downtown financial center under Central National Bank between 1945 and 1960. From 1962 into the late 1990s, Rock River Savings & Loan Association and its successors, Melrose Park-based Life Savings of America and Minneapolis's TCF Bank, anchored the Enterprise Building.

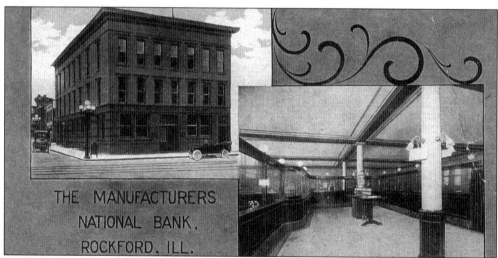

THE MANUFACTURERS NATIONAL BANK, ROCKFORD, ILL.

MANUFACTURER'S NATIONAL BANK (CROTTY BLOCK), 327-29 EAST STATE STREET, 1924. Founded by prominent manufacturers W.F. Barnes and N.C. Thompson, Manufacturer's National Bank (1888–1931) became one of Rockford's leading banks. In 1926, Manufacturer's relocated from this headquarters on the southwest corner of East State and First Streets to its newly-constructed, eight-story Classical Revival-styled Manufacturer's National Bank Building at 425 East State, which became Rockford City Hall in 1937. Razed in 1972, this site was redeveloped in 1973 into an enduring urban mini-park featuring walkways, benches, and plantings of pin oak and evergreens. The $7,000 project was a cooperative effort of neighboring First National Bank and Eye-Delight, a grass roots civic beautification organization. (Courtesy: Mark D. Fry)

14

MAIN STREET, NORTH FROM PEACH (WEST JEFFERSON) STREET, 1925. With the exception of the enduring *c.* 1904 American Insurance Co. Building (left), at 304-06 North Main, one sees a dramatically different view today. Within a few years, downtown Rockford's rapid commercial expansion would radically transform the 300 block of North Main with three now-familiar developments: the National Register-listed Coronado Theater (*c.* 1927) and two Art Deco gems—the eight-story Gas & Electric Building at 303 North Main and architect Jesse Barloga's *c.* 1931 green and gold terracotta Liebling Building, a city historic landmark at 330 North Main. Sadly demolished in 1986 was the Tebala Shrine Temple (right background) at 323 North Main.

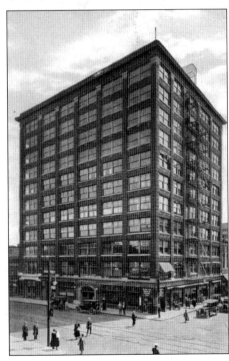

ROCKFORD NATIONAL BANK BUILDING, 202-06 WEST STATE STREET, 1926. Built as a seven-story banking and office building in 1907, an additional four stories and West State frontage were added to Rockford National Bank's Commercial-styled "skyscraper" in 1922. Long the city's tallest office building, the Rockford Trust Building was eclipsed in size and stature by the 13-story Talcott Building in 1927. The city's leading banking house, "Big, Strong Bank" Rockford National (1871–1931) anchored the Trust Building until its Great Depression demise. Still a familiar figure on downtown's west side skyline, the Trust Building continues to house a variety of professional offices and street-level retail enterprises.

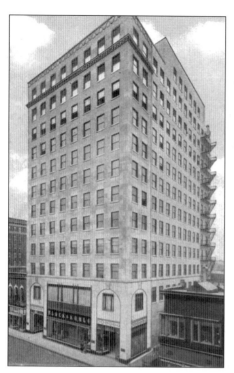

TALCOTT BUILDING, 315-21 WEST STATE STREET. Designed by Chicago architect Howard Shaw Associates, the $600,000 Beaux Arts-styled Talcott Building was built between 1925 and 1927 by Wait Talcott, a Rockford textile manufacturing executive and former state legislator. The 13-story structure was named in honor of Talcott's late grandfather, William, a prominent 19th century Rockford agricultural implement manufacturing executive with Emerson, Talcott & Company. Rockford's tallest office building, the prestigious Talcott Building would also prove to be a popular downtown shopping destination, anchored from 1927–70 by Peoria-based department store Block & Kuhl and its Windy City successor, Chicago's Carson Pirie Scott & Company.

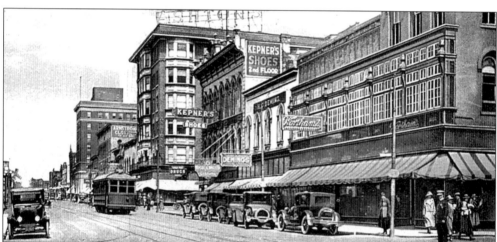

LOOKING WEST ON STATE STREET FROM WYMAN STREET, 1925. The heart of Rockford's Loop retail district, popular anchors included Horace L. Wortham's women's wear store, 201-05 West State, and A.C. Deming Dry Goods & Millinery (1895–1927), 207-09 West State. Founded in 1907, Wortham's (Lane Bryant) relocated from the Italianate *c.* 1864 Richardson Building (right) to suburban CherryVale Mall in 1973. In 1931, Deming's and the western section of Wortham's were redeveloped for a now landmarked, Art Deco-styled W.T. Grant Co. 25¢ to one dollar variety store. Popular Grant's relocated to Rockford's new Colonial Village Mall in 1962. The Italianate *c.* 1876 Samuel Stern Block (center), since clad in Art Deco veneer, housed Simon Pure Drug Co., Vogel & Wallen Clothing, and Kepner's Shoes. "Skyscrapers" include Ashton's Dry Goods Co. and Forest City National Bank. Restaurants Subway and Paragon on State today anchor the Richardson and W.T. Grant buildings.

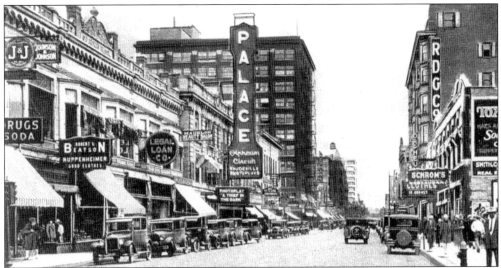

NORTH MAIN STREET LOOKING SOUTH FROM MULBERRY STREET. Downtown Rockford's cosmopolitan Loop bustled with activity in the Roaring Twenties. North Main business anchors included Orpheum Circuit's Palace (1915–53) and Orpheum (1901–37) theaters, department store Rockford Dry Goods Co. (1878–1974), and Schrom's Restaurant (1915–51). Between 1956 and 1983, the remodeled Palace housed Rockford's F.W. Woolworth Co. five-and-dime flagship. A familiar sight is the 11-story Rockford Trust Building, 202-06 West State Street. North Main urban renewal in 1984 claimed the *c.* 1896 C.F. Henry Block (left), the *c.* 1915 Palace, and the six-story, *c.* 1904 Rockford Dry Goods Co. Building (right). Home to a two-block pedestrian mall since 1975, Main Street, between Mulberry and Elm, today operates as a specialty retailing, entertainment, and arts district. (Courtesy: Mark D. Fry)

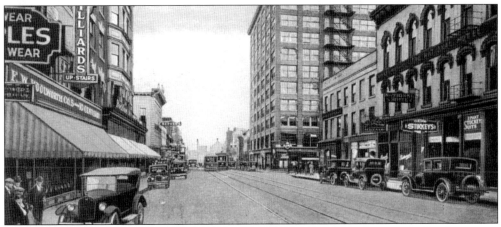

CORNER OF STATE AND MAIN. The hub of Rockford commerce, the Loop offered a variety of popular retailers. At left are national five-and-dime F.W. Woolworth Co. and Rockford Dry Goods. Both buildings were razed in 1984 for a 5-story, 300-car municipal parking deck. At center is Rockford National Bank's enduring 11-story Trust Building, 202-06 West State. At right (from left) are John R. Porter Company's popular "Porter's Corner" pharmacy and the *c.* 1872 Horsman Block, anchored by Stuckey's Clothing and the 45-room National Hotel. Porters and the Horsman Block were razed for the enduring *c.* 1929 Art Deco-styled Pen-Met Building, part of today's *c.* 1987 Stewart Square office and retail development.

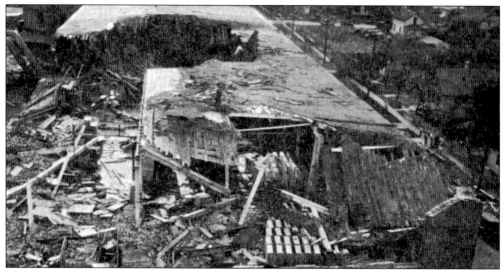

UNION FURNITURE CO., 1827 18TH AVENUE, 1928. Rockford's sky darkened ominously at 3:30 p.m. on September 14, 1928. Within three minutes, a tornado cut a $2 million swath of destruction across the southeast side, killing 14 and injuring 36 in what remains the deadliest natural disaster in Rockford's 170-year history. Four factories, three warehouses and 360 homes were damaged or destroyed. At Union Furniture Co., the tornado claimed the life of employee Axel Ahlgren, 40. Some 200 emergency personnel from Rockford's police and fire departments, the Winnebago County Sheriff's Department, and the Illinois State Patrol responded to the disaster, augmented by emergency crews from Belvidere, Freeport, Dixon, and Beloit. A local "subscription drive" by Rockford residents raised over $40,000 for tornado victims. (Courtesy: Mark D. Fry)

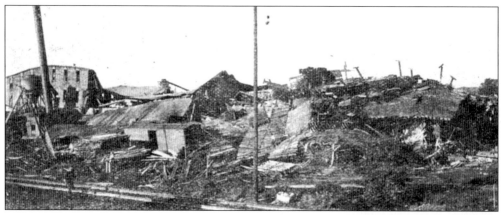

ROCKFORD CHAIR CO. FACTORY B, 1928. The infamous "Rockford Cyclone" struck the southeast side with horrific, deadly force. Hardest-hit was Rockford Chair & Furniture Company's four-story "Factory B" near the tornado's Blackhawk Park touchdown point. Factory B accounted for eight of Rockford's fourteen tornado fatalities: Olaf Larson, 27; Herman Wydell, 47; Martin Anderson, 34; August J. Peterson, 52; Frank Strom, 34; Gunnar Ryden, 29; George Fagerstrom, 51; and John Brunski, 45. Rockford's 1928 tornado, though deadly, would be eclipsed locally on April 21, 1967, by a $25 million Belvidere tornado that killed 25, including 18 at Belvidere High School. Other damaging Rockford tornadoes struck in July 1863 and July 1913. (Courtesy: Mark D. Fry)

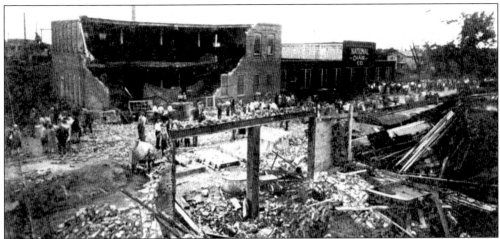

NATIONAL CHAIR CO. AND ELCO TOOL CO., 1928. Rockford's tornado demolished several factories, including National Chair Co., 1827 Broadway, and Elco Tool Co., 1800 Broadway. Founded in 1922, Elco relocated in 1957 to a state-of-the-art $2.7 million factory at 1111 Samuelson Road near Greater Rockford Airport. Today a leader in the nation's fastener, metal stamping, and engineered assembly markets, Elco specializes in the production of specialty metal and plastic parts and components. Since 1995, Elco has been a division of Rhode Island-based Textron, whose holdings also include old-line Rockford manufacturers Greenlee Brothers Co. (*c.* 1862) and Camcar (*c.* 1943). Local Textron Fastening Systems employment has been pared substantially in recent years as Textron shuttered most area Elco and Camcar plants in favor of Textron facilities elsewhere.

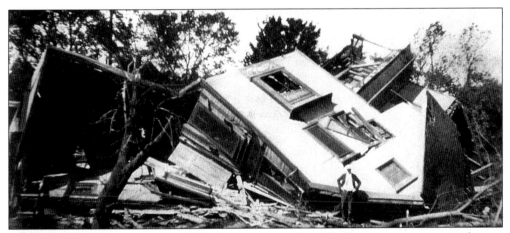

NO. 5, ROCKFORD CYCLONE, 1928. Damage from Rockford's late summer tornado was widespread across the southeast side, with 1,200 left homeless. The cyclone, estimated at 100 yards wide, left a four-mile northeasterly path of destruction from Blackhawk Park to Twenty-second Street and Seventh Avenue. Some 360 Rockford homes were damaged or destroyed, including this residence at 1102 Twentieth Avenue, which was rented by newlyweds Mr. & Mrs. John Houser. Four of Rockford's fourteen fatalities came in southeast side residential areas. Spring Valley resident Tony Markinkas, 50, was killed inside his boarding house. A flying garage roof at Seventh Street and Seventeenth Avenue killed three Rockford teenagers—brothers Bernard and Virgil Cornmesser and their cousin, Everitt Cornmesser. (Courtesy: Mark D. Fry)

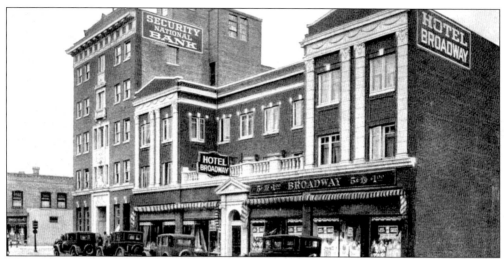

SECURITY NATIONAL BANK AND HOTEL BROADWAY, 1100-11 BROADWAY, 1929.
Development of a Swedish-influenced retail district along Fourteenth Avenue between Kishwaukee and Eleventh Streets was spurred by the construction of the Illinois Central's *c.* 1905-06 southeast side industrial belt-line, which drove nearby industrial, residential, and commercial development. Renamed Broadway in 1923 as its prestige grew, the 1920s brought an explosion of development, including these 1926 projects—Gust Blomquist's 47-room Hotel Broadway and a $300,000 high-rise headquarters for Security National Bank (1920–30). Both structures, later home to banks City National, First of America, and National City, today house Crusader Clinic.

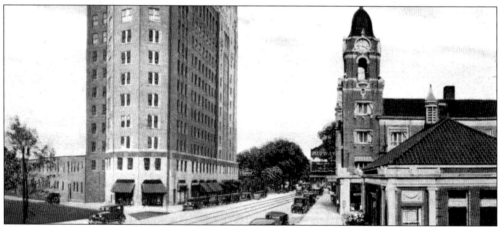

FAUST HOTEL AND EAST STATE STREET, 1931. This classic Rockford streetscape remains a familiar sight. At left is the 400-room, *c.* 1930 Hotel Faust, at 630 East State. The $2.7 million Art Deco-styled hotel today houses Faust Landmark, a 200-unit residential development for seniors and the disabled. Distinguished by its 90-foot clock tower is Chicago architect J.E.O. Pridmore's enduring 2,000-seat Midway Theater, at 721 East State. The Spanish Renaissance-styled, *c.* 1918 Midway today hosts periodic live performances. At right is the *c.* 1920 Shumway Market Building, at 713 East State. Today housing the Rockford Area Arts Council, Rockford architect Charles Bradley's "Roadside Picturesque/Neo-Classical" structure originally housed restrooms and offices for the Shumway public farmer's market, a city fixture since 1904. Both the Midway and Shumway are Rockford and National Register landmarks.

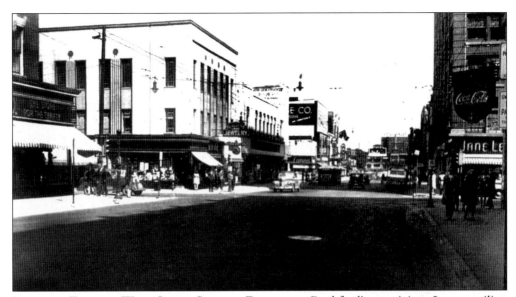

Looking East on West State Street. Downtown Rockford's prestigious Loop retailing district, centered around West State and Main Streets, offered this bustling scene in the 1930s and 1940s. Businesses include (from left): the Rockford Dry Goods Co. department store, Busch Jewelers, variety store W.T. Grant Co., Wortham's Ladies Wear, Comay's Jewelers, department store Charles V. Weise Co., the State Theater, the Jane Lee dress shop in the Rockford Trust Building, and, at extreme right with the Coca-Cola sign, John R. Porter Company's popular "Porter's Corner" drug store and soda fountain. Visible in the distance at center right is the towering 11-story Hotel Faust. (Courtesy: Mark D. Fry)

West State Street, Looking East from Main Street. The 13-story Talcott Building provided this dramatic 1940s aerial of downtown's vibrant Loop retail district. At left is the flagship Charles V. Weise Co. department store, 117 West State, and the towering Art Deco-styled Hotel Faust, 610 East State. At right are the 11-story Rockford Trust Building and the 8-story riverfront Rockford News Tower. At extreme right foreground, 302-08 West State, is the *c.* 1929 Pen-Met Building, named for major anchors J.C. Penney and variety retailer Metropolitan Store. The Art Deco Pen-Met also housed leading druggist John R. Porter Co., a "Porter's Corner" fixture since 1859. Occupied by Penney's and an expanded D.J. Stewart & Co. (1866–1985) department store following Metropolitan's 1959 closure and Porter's 1965 demise, the Pen-Met sat vacant following the shuttering of Stewart's in 1977 and Penney's in 1980. In 1987, a $2 million redevelopment transformed Pen-Met and the adjoining *c.* 1890 Stewart Block, 113-117 South Main, into the Stewart Square office and retail complex.

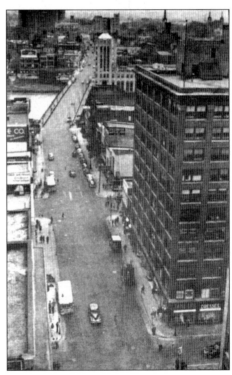

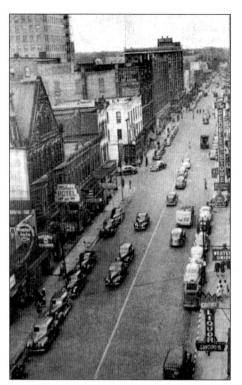

SOUTH MAIN STREET, LOOKING NORTH FROM CHESTNUT. This World War II-era aerial from the William Brown Building shows a bustling South Main Street. Pictured at left are the Milner Hotel & Cafe, the Elms Hotel, department store D.J. Stewart & Co., the Pen-Met Building, Rockford Dry Goods Co., and the towering 13-story Talcott Building. Small businesses anchoring South Main's 200 block included clothier Julian Goldman's People's Store, Western Union, Crown Liquor Shoppe, auto parts retailer Western Auto, and the Phoenix Cleaners shop operated by immigrant Greek brothers George and Joseph Koplos. The popular 70-room Milner Hotel, 209-11 South Main, operated under the Illinois and Milner names from 1908–65. Urban renewal in the 1970s saw the bulk of the 200 block of South Main, except for the William Brown Building, redeveloped for the 10,000-seat Metro Center civic auditorium/arena (left) and surface parking (right).

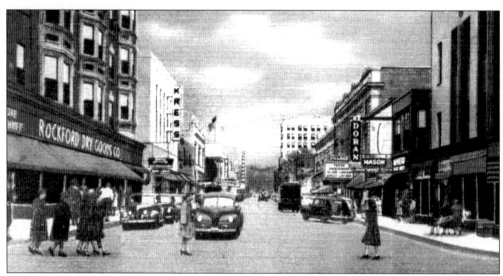

CORNER OF STATE AND MAIN, "ROCKFORD'S HUB." Downtown's prestigious west-side Loop retailing district was still in its heyday at the time of this World War II-era postcard. North Main Street business anchors pictured here include: (from left) department store Rockford Dry Goods Co., the Brook's Nut House candy and nut shop, the S.H. Kress & Co. five-and-dime variety store, Walgreen's, Bishop's Buffeteria, the Coronado and Palace theaters, W.B. Doran Men's Store, Mason Shoe Store, and (at far right) Mangel's Ready-to-Wear. The towering eight-story Art Deco-styled Gas & Electric Building, opened in 1931, is seen in the distance at right center.

S.H. KRESS & CO., 116-18 NORTH MAIN STREET, 1945. In 1937–38, New York-based "5, 10, and 25 cent" variety store giant S.H. Kress & Co. (1896–1980) built this Art Deco store on the site of Rockford's old Orpheum Theater, reborn as the landmark 650-seat Art Moderne-styled *c.* 1937 Times Theater, at 226 North Main. One of 262 stores operated nationwide in 30 states at Kress's mid-1950s height, this Rockford outlet was one of eight downtown department and variety stores as late as 1970. Faltering Kress closed its Rockford store in 1974. In 1986, the long-vacant Kress Building was purchased by New American Theater (*c.* 1972) and remodeled into a $1.6 million, 282-seat live performance playhouse. Praised by the Chicago *Tribune* as the "crown jewel of Rockford," NAT is one of only eight Illinois "arts treasure theaters."

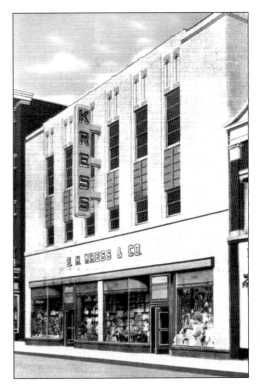

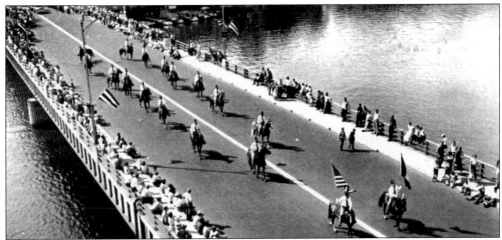

CENTENNIAL PARADE, JUNE 7, 1952. Among the city's mid-century highlights were the June 7-13, 1952, "Centennial Days" civic celebrations held to commemorate Rockford's incorporation as a city. Among the major observances was this "giant" hour-long downtown kick-off parade, seen heading east over the State Street Bridge from the Rockford News Tower. The parade crowd, estimated at over 100,000 spectators, was billed in local newspapers as the "biggest mass gathering in the city's history." Centennial festivities also included carnival rides at Roper Field, "giant aerial fireworks," a Coronation Ball, and "Centurama" Rockford history dramas at Beyer Stadium. Rockford's popular 1984 sesquicentennial celebration, On the Waterfront, would grow into an annual event that today ranks as Illinois's largest music festival. (Courtesy: Mary Lou Liebich Yankaitis)

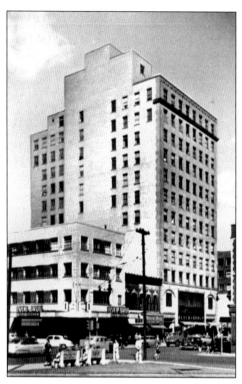

NU-STATE AND TALCOTT BUILDINGS. One of downtown Rockford's early, major post-Depression commercial developments would be developer Max Liebling's low-rise Nu-State retail and office building on the northeast corner of West State and Church Streets, at 331 West State. Osco Drug, a Rockford retail presence since 1943, anchored Nu-State from 1951–83. Just a few doors east, at 315-21 West State, Peoria-based department store chain Block & Kuhl Co. and its Chicago successor, Carson Pirie Scott & Co., were longtime 1927–70 fixtures of the 13-story Talcott Building, one of Rockford's most prominent office and retail buildings. The Nu-State, renamed "119 North Church" in recent years, is today anchored by Downtown Discount Drug. (Photo: Jack Taylor)

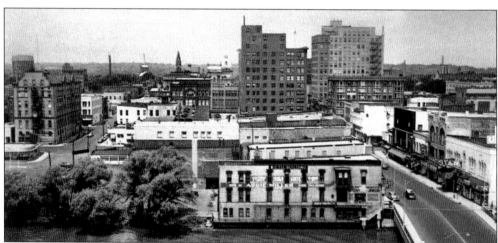

WEST SIDE SKYLINE, EARLY 1950s. Following the Roaring Twenties "skyscraper" building boom that spawned an expanded 11-story Rockford Trust Building and the 13-story Talcott Building (center, left and right), large scale downtown development was scarce from the early Great Depression until Rockford's 1970s embrace of urban renewal. Seen at bottom right, looking west from the Rockford News Tower, is the $600,000 State Street Bridge, built in 1948–49. Figuring prominently (from left) are the *c.* 1900 Empire Building, the Women's Christian Temperance Union's riverfront Minard Block "W.C.T.U. Building," and Rockford's aging West State business district, anchored by Rockford Dry Goods Co., Charles V. Weise Co., and the State Theater. In the distance at center are the towers of St. Mary's Catholic Church and the Winnebago County Courthouse. (Photo: Jack Taylor)

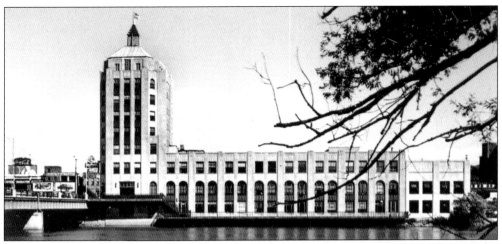

ROCKFORD NEWS TOWER, 99 EAST STATE STREET. Rockford Consolidated Newspapers' eight-story Rockford News Tower has been a skyline signature building since the Great Depression. Clad in Bedford limestone, black Coldwater Springs granite, and cast aluminum, the News Tower was designed by leading Rockford architect Jesse Barloga (1888–1947) in a Gothic-inspired Art Deco style. Built in 1928–32, the $750,000 News Tower would house Rockford's merged *Morning Star* and afternoon *Register-Republic* dailies, today's Gannett-owned *Register Star* (*c.* 1855). From 1932–62, the News Tower also housed WROK-AM 1440 (*c.* 1923 as KFLV) and WZOK-FM 97.5 (*c.* 1949). Additions were built in 1945, 1966, 1990, and 1998. During his distinguished 1919–47 career, Pecatonica-born Barloga designed over 450 structures in Rockford, Freeport, and Byron. (Photo: Jack Taylor)

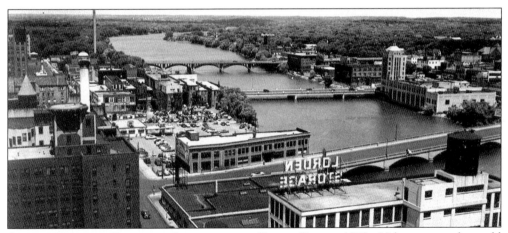

AERIAL VIEW OF BUSINESS SECTION AND ROCK RIVER, 1958. Urban renewal would dramatically alter downtown's west bank, starting with the 1960 demolition of the Nelson Hotel (left foreground). Since the 1970s, urban renewal transformed downtown's Wyman Street riverfront, between Chestnut and Mulberry (center left), with the *c.* 1989 E.J. "Zeke" Giorgi State Office Building, the *c.* 1975 United Bank (National City) Plaza, and the *c.* 1979 Luther Center senior high-rise. The 1991–95 redevelopment of west bank properties south of Chestnut (foreground right) created the six-acre, $6.9 million Davis Park at Founders Landing outdoor concert and festival venue. The redeveloped seven-story Lorden Storage warehouse, built in 1916–17 as a women's hosiery plant, serves as the park's anchor facility, home to Davis's Great Lawn and Left Bank stages. (Photo: Jack Taylor)

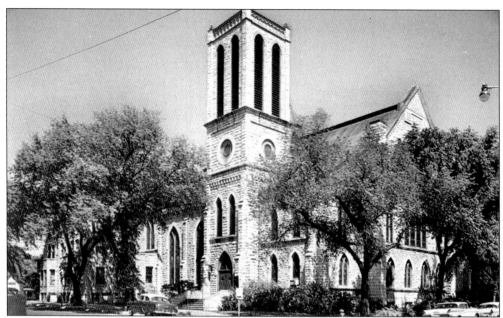

DUTCH ELM DISEASE DEVASTATION. Downtown's *c.* 1887 Court Street United Methodist Church serves as a picturesque backdrop in these postcards vividly illustrating the devastation wrought on "Forest City" Rockford by Dutch elm disease between 1953 and 1962. Spreading across the United States from New York City and Cleveland since the arrival of diseased French logs in 1930, Dutch elm disease's northern Illinois arrival quickly stripped Rockford streets of their once-ubiquitous American elm canopies. City leaders and voters, employing a do-nothing strategy, watched Rockford's stock of American elms thin at a rate of 1,000 trees weekly at the outbreak's peak. When the epidemic subsided in 1963, over 40,000 of the city's 47,000 American elms were dead and the city had spent $1.25 million removing diseased trees. Noted the Rockford *Register-Republic* of the denuded city, "Rockford tried looking the other way. When the city looked back, its trees were gone." (Top Photo: Henry Brueckner, Bottom Photo: Harvey W. Olson)

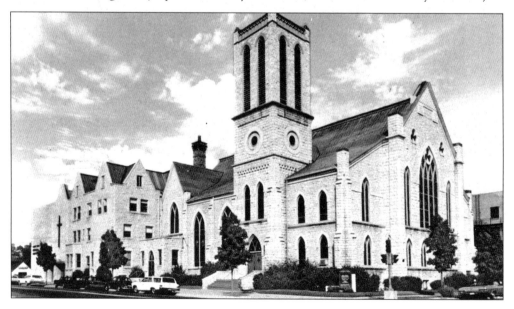

GAS & ELECTRIC BUILDING, 303 NORTH MAIN STREET, 1956. Built in 1929–31, architect Willys Hubbard's eight-story, $425,000 Art Deco-styled Gas & Electric Building still cuts an imposing profile on West Jefferson Street between North Main and Wyman. Long anchored by Rockford-based Central Illinois Electric & Gas Co. (1861–1966), upper floors housed general, medical, and dental offices and quarters for the Rockford University Club. CIE&G largely vacated its headquarters following its acquisition by Commonwealth Edison. In 1987, the Gas & Electric Building was sold to Rockford-based PioneerLife (1926–1997), which undertook a $3.5 million renovation of its renamed PioneerCentre. Following Pioneer's $477 million, 1997 sale to Indiana-based Conseco, Inc., Pioneer's once-sizeable Rockford operations were downsized and then eliminated altogether by 2003. In 2002, Conseco sold the building to Capital Acquisitions and Management Co., which relocated its Sycamore, Illinois headquarters to Rockford. (Photo: Jack Taylor)

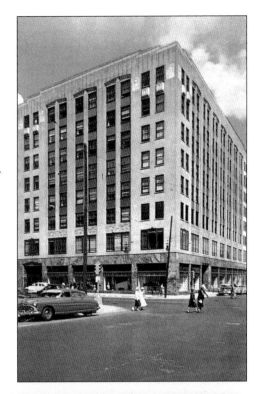

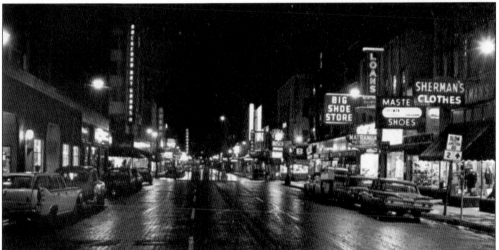

SOUTH MAIN STREET LOOKING NORTH FROM ELM STREET, 1963. Red, pink, orange, and blue neon signs cast a colorful reflection on rain-slicked Main Street in downtown Rockford's waning heydays. Anchor retailers include, from left: department store D.J. Stewart & Co.; the John R. Porter Co. pharmacy; department store Rockford Dry Goods Co.; variety store S.H. Kress & Co.; the Coronado Theater; "dime store" F. W. Woolworth Co.; W.B. Doran Men's Store; Busch Jewelers; Big Shoe Store; Northern Illinois Credit; Matranga Photography; Ruth D. Clark Lingerie/Mary DeFay Casuals; Masters Shoes; and Sherman's Clothes. While the Coronado Theater and Busch Jewelers endure in Rockford today, only the Coronado remains a downtown presence as one of fewer than 40 operational "atmospheric" theaters in the nation.

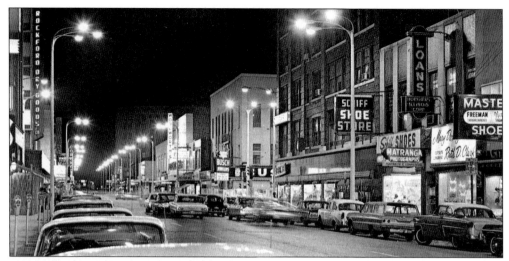

SOUTH MAIN STREET LOOKING NORTH FROM ELM STREET, 1965. Rockford boasted the "brightest downtown in the world" following the April 1965 debut of this new $250,000 lighting system, installed in a 20-square-block area bounded by Chestnut and Winnebago Streets, Park Avenue, and the Rock River. The new lighting system, part of a 1962 Downtown Council plan for injecting renewed life into Rockford's declining Loop retail district, failed to dim consumer preferences for new, parking-rich, hassle-free outlying shopping centers, which siphoned shoppers and sales volume and eventually hastened the relocation or closure of many downtown retailers. Today, only the newly restored *c.* 1927 Coronado Theatre, 312-24 North Main, remains. (Photo: Henry Brueckner)

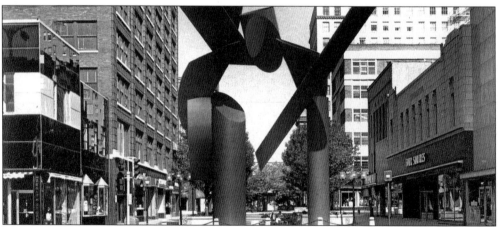

DOWNTOWN MALL, 1978. In the 1960s and 1970s, Rockford's downtown Loop declined at the auto-driven hands of outlying shopping malls and east side commercial sprawl toward I-90. A major 1974–75 downtown renewal initiative was Chicago developer Barton-Aschman Associates' $1.24 million, four-block outdoor pedestrian mall encompassing the Loop's West State and Main heart. *Symbol*, a 47-foot, 30-ton metal sculpture by internationally famed New York artist Alexander Liberman, anchored the mall's State-and-Wyman entrance from 1978–83. Doomed by scarce parking, a significant loss of retailers, and the new CherryVale Mall, the pedestrian mall failed to attract a significant clientele. State Street reopened to traffic in 1984. In recent years, the Loop has experienced a renaissance as an entertainment, arts, dining, and niche retailing district. (Photo: Henry Brueckner)

LUTHER CENTER, 111 WEST STATE STREET. Urban renewal of Rockford's West State Street riverfront in the mid-to-late 1970s was writ large with the 1976–79 construction of the 16-story, 202-unit Luther Center senior high-rise. Built on the longtime site of the State (Palm) Theater and Rockford-based Charles V. Weise Company's flagship department store, the $5.8 million Luther Center, designed by Architektur 80, was a collaborative project of the American Lutheran Church, the Illinois Synod of America, and the Missouri Synod-Northern District—the first pan-Lutheran project of its type in the nation. (Photo: Bert E. Johnson Photography; Courtesy: Mary Lou Liebich Yankaitis)

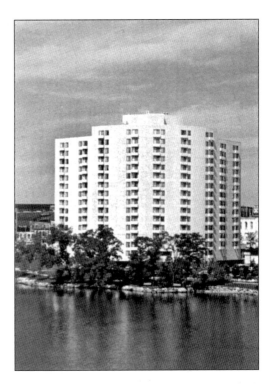

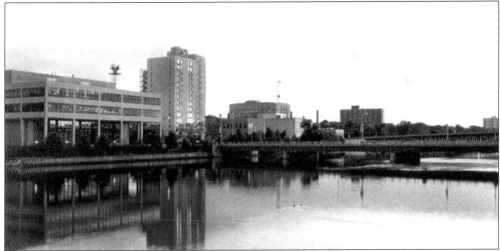

DOWNTOWN RIVERFRONT, 1980s. During the 1970s, Rockford embraced large-scale urban renewal initiatives in a bid to revitalize its declining downtown, redeveloping the west bank riverfront along West State Street and a several block corridor bounded by the Rock River and Elm, Chestnut, and Court Streets, the latter now home to the E.J. "Zeke" Giorgi State of Illinois Office Building (1987–89), the $15.3 million Rockford MetroCentre (1978–81), the Concourse parking deck, the Federal Courthouse, and the IBM Building—the Winnebago County Administration Building since 1992. The riverfront 100 block of West State (left) was redeveloped with these two dramatic structures architect Orput & Associates' $4 million United Bank of Illinois (National City Bank) Plaza (1973–75), 120 West State Street; and the 16-story, 202-unit Luther Center senior high-rise (1976–79). (Photo: John Babcock)

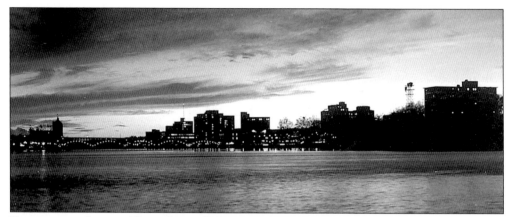

DOWNTOWN SUNSET VIEW, LATE 1990S. Tough economic times in the mid-to-late 1970s and Rockford's "Second Depression" in the early 1980s saw Rockford's population shrink for the first time since the Great Depression, contracting from 147,370 in 1970 to 139,712 in 1980. An improved and increasingly diversified local economy, coupled with aggressive annexation under three-term mayor Charles Box (1989–2001), helped increase Rockford's population, albeit slowly. Rockford's population, which rose negligibly to 140,003 in 1990, now stands at 151,170—Illinois's third-largest city behind Chicago and new "Second City" Aurora. (Photo: Nels Akerlund Photography)

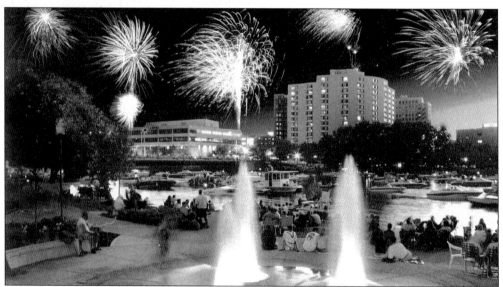

MILLENNIUM FOUNTAIN, NORTH WATER STREET, 2001. Since Rockford's 1834 founding, the Rock River has been the city's greatest natural asset, powering Rockford into a national manufacturing center and serving as a leading recreational attraction. In an ongoing effort to reclaim Rockford's downtown riverfront for public use—a dream first outlined in the city's c. 1918 (George D.) Roper Plan—a $350,000, public/private 2000–01 initiative by the Rockford 2000 Alliance created the award-winning Millennium Fountain at Waterside Park. Downtown Rockford's west side skyline anchors, including (from left) National City Bank Plaza, the Rockford Trust Building, Luther Center, the Talcott Building, and the Rockford Public Library, serve as a cosmopolitan backdrop for the colorful Millennium Fountain during Rockford's annual Fourth of July fireworks extravaganza. (Photo: Tom Claybough Photography)

Two
THE PUBLIC DOMAIN

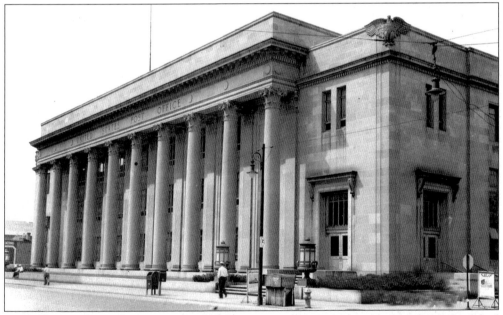

U.S. POST OFFICE AND FEDERAL BUILDING, 401 SOUTH MAIN STREET. With Rockford deeply mired in the throes of the Great Depression, the federal Works Project Administration's (WPA) 1932–33 construction of Rockford's new 90,000-square-foot U.S. Post Office and Federal Building was an event of great celebration, drawing a groundbreaking crowd of 10,000. Rockford U.S. Congressman John T. Buckbee, a 10-year Washington politico, laid the cornerstone and later dedicated the new post office. This $735,000 Neo-Classical Revival structure, designed by prolific Rockford architects Edward Peterson and Gilbert Johnson, served as Rockford's main postal facility until 1972 and as Rockford's federal building until a replacement opened at 211 South Court Street in 1978. Since renamed Post Office Place, major tenants include the Rockford Park District, a postal substation, and FOX affiliate WQRF-TV 39. The grandeur of the interior metalwork and sumptuous marble showcases the fine craftsmanship performed by Depression-era WPA craftsmen.

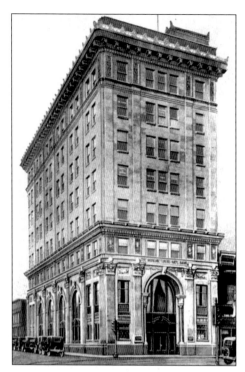

ROCKFORD CITY HALL, 425 EAST STATE STREET. Built in 1926 by Rockford's high-flying Manufacturer's National Bank (1888–1931), this eight-story Bedford stone and granite, Classical Revival-styled skyscraper was designed by leading city architects Edward Peterson and Gilbert Johnson. Vacant following the bank's Great Depression closure, the Manufacturer's National Bank Building was purchased by the City of Rockford in 1937 for use as its new city hall. Between 1992 and 1994, a $10.8 million renovation and expansion restored the building's magnificent two-story lobby and added a two-story East State Street annex immediately west of City Hall. Rockford City Hall has been awarded landmark status by the City of Rockford Historic Preservation Commission.

ROCKFORD SANITARY DISTRICT, 3300 KISHWAUKEE STREET, 1950. The Rockford Sanitary District, today's Rock River Water Reclamation District, was created in 1926 in a bid to address Rock River pollution problems. At the time, Rockford alone discharged some 9 million gallons of raw sewage and industrial waste into the Rock daily, prompting city health commissioner Dr. N.C. Gunderson to proclaim the river a "large cesspool." A $2.63 million, 1928 bond issue funded the construction of a municipal sewer system and this sewage treatment and administrative facility, opened in 1932. This facility, since enlarged, services Rockford, Loves Park, and portions of surrounding townships.

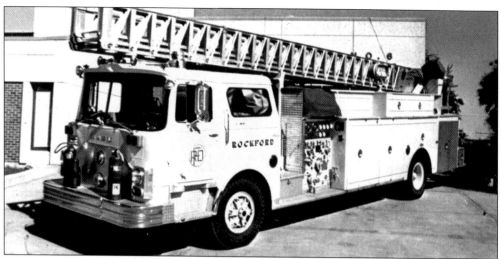

STATION NO. 6, 3329 WEST STATE STREET, 1977. The Rockford Fire Department's new Station 6 and adjacent Wayne E. Swanson Fire Academy opened in 1974, built with nearly $700,000 in federal grants and local monies. Pictured outside Station 6 is one of three new 1976 Mack-Pirsch Quint fire engines, deployed at Stations 6, 9, and 12. Encompassing ground ladders, a 75-foot aerial ladder, a water tank, and a 1250 g.p.m. water pump, the multi-purpose Quint allowed a reduction in units required for fire calls, cutting personnel and equipment costs in tight economic times. Other major 1970s RFD changes included the City of Rockford's 1977 transfer of emergency medical services from the police department, and the 1978 addition of the department's first female firefighter. (Photo: Roy L. Anderson)

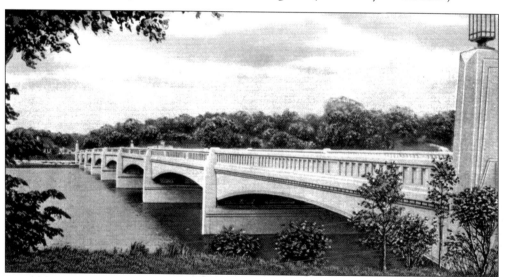

AUBURN STREET BRIDGE. This modern, *c.* 1937 concrete span linking Auburn Street and Spring Creek Road replaced Rockford's steeply arched "High Bridge" or "North End Bridge," an often treacherous and aggravating *c.* 1900 span built with a 7.4 degree grade to accommodate the popular excursion steamship *Illinois* (1900–24). Widened in 1969 to handle increased traffic flow as Rockford grew to the north and east, this span was replaced with a $3.6 million bridge in 1985–87. Auburn Street served as metro Rockford's northernmost bridge until suburban Loves Park opened its $1.1 million Riverside Boulevard Bridge in 1954.

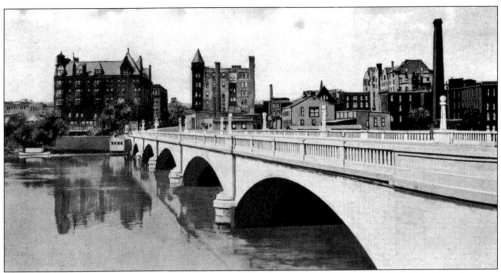

CHESTNUT STREET BRIDGE, 1920. Rockford's second span linking Chestnut and Walnut Streets, this steel and concrete bridge opened in 1917. West side skyline anchors include (from left) the Nelson Hotel, the William Brown Building, the Empire Building, and the riverfront factory of Rockford Silver Plate Co. (1882–1956). Razed in 1931 for a widened Wyman Street, the Silver Plate site today houses the $9.3 million, *c.* 1989 E.J. "Zeke" Giorgi State of Illinois Office Building. The legacy left by Rockford Democrat Giorgi, Illinois's longest-serving House member (1965–93), includes the Illinois Lottery, I-39, New American Theater, Riverfront Museum Park, the University of Illinois College of Medicine at Rockford, the 10,000-seat MetroCentre civic center/arena, the State of Illinois office building, and Northern Illinois University's $5.4 million, *c.* 1995 satellite Rockford campus.

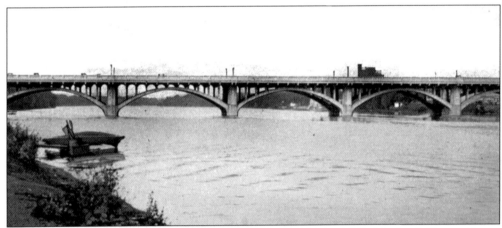

JEFFERSON STREET BRIDGE. Built at a cost of $360,000 in 1925–26, the Jefferson Street Bridge drew protests from citizens, business leaders, and newspaper editors as being unnecessary, too high, and too expensive. Despite protests, the Jefferson Street Bridge was built to its original design by then-city engineer Bernard C. Harvey, who considered the project one of the favorites of his six-year tenure. Completion of the bridge saw the west side's Peach Street renamed West Jefferson. A decorative $90,000 lighting system highlighting the bridge's distinctive, graceful arches, funded by Build Illinois, was installed and dedicated in August 1987, with 95-year-old Harvey throwing the switch.

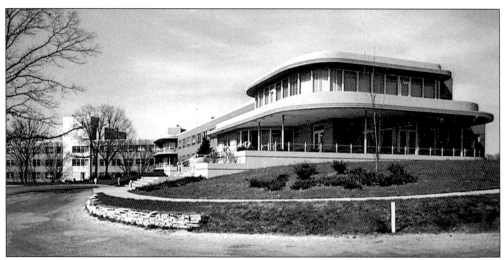

ROCKFORD MUNICIPAL TUBERCULOSIS SANITARIUM, 1601 PARKVIEW AVENUE.
Tuberculosis (TB), an airborne bacterial disease, once claimed the lives of millions worldwide.
Until a pharmaceutical cure was discovered in 1950, the most effective solution for dealing
with TB was sanitarium isolation of the infected from potential victims. Built in 1916 on a
scenic 19-acre site overlooking Sinnissippi Park, the Rockford Municipal Tuberculosis
Sanitarium (RMTS) offered free TB treatment to city residents. Expanded in 1917 and 1927,
this $698,333 Streamline-styled facility was built on the site of the RMTS's *c.* 1916 main
building in 1949–50. In 1971, the RMTS facility was sold to the University of Illinois for the
establishment of the much-expanded University of Illinois College of Medicine at Rockford.

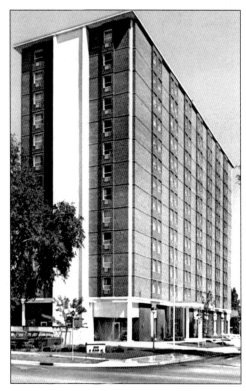

NORTH MAIN MANOR APARTMENTS, 505
NORTH MAIN STREET. In an effort to provide
Rockford's elderly and poor with safe,
affordable housing, the Rockford Housing
Authority (RHA) constructed an ambitious
1,495-unit slate of elderly and low-income
housing developments between 1967 and the
mid-1970s. Low-income RHA housing
developments included Fairgrounds Park and
238 housing units scattered around the city. As
part of its efforts, the RHA also built several
elderly-exclusive "low cost rental"
independent living downtown high-rises,
including Park Terrace at 1000 Chamberlain
Street; Oleson Plaza at 511 North Church
Street; Campus Towers at 505-15 Seminary
Street; and the 187-unit, 13-story North Main
Manor, built in 1967–68 on the site of the *c.*
1847 Goodyear Asa Sanford home.

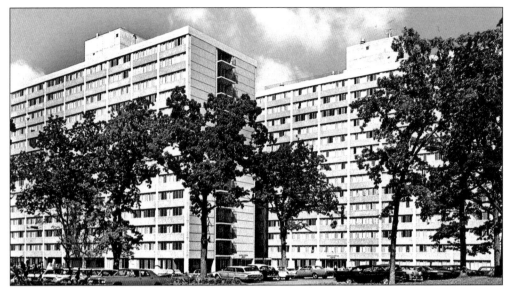

CAMPUS TOWERS, 505-15 SEMINARY STREET. Following the 1964 relocation of Rockford College to its new $17 million greenfield campus development at 5050 East State, the Rockford Housing Authority redeveloped Rockford College's idled downtown campus in 1969. With the exception of the contemporary 1950 Jewett Lab Building, today's Winnebago County Health Department, the remaining campus was razed and redeveloped for the RHA's 14-story, twin tower Campus Towers complex. Since renamed Brewington Oaks, 418-apartment Campus Towers was built to provide low cost rental apartments for the elderly and disabled.

ILLINOIS NATIONAL GUARD ARMORY, 605 NORTH MAIN STREET. Built by the federal Works Project Administration in 1936–37, the $256,000 Gothic/Art Deco Illinois National Guard Armory is a national, state, and city landmark. The headquarters of the 129th Illinois National Guard and Illinois 44th Infantry Division, the 4,000-seat armory in pre-MetroCentre days hosted over 250,000 people annually for community and civic events. Notable Armory guests include first lady Eleanor Roosevelt, presidents John F. Kennedy and Richard M. Nixon, and entertainers Woody Herman, Gene Autry, Nat King Cole, and Fleetwood Mac. Vacated in 1993 following the guard's relocation to suburban Machesney Park, the armory was later home to OIC Vocational Institute. Now vacant, the structure awaits reuse.

WINNEBAGO COUNTY COURTHOUSE, 400 WEST STATE STREET. Having outgrown Chicago architect Henry L. Gay's distinctive French-Venetian-American 1878 courthouse (right), Champaign architect J.W. Royer's now-landmarked $326,000 Neo-Classical Revival "Annex" (left) was built at 403 Elm Street in 1916–18. The architectural character of Courthouse Square would further change with the $160,000, *c.* 1957 Youth Welfare Building at 401 Elm. The 1878 courthouse, outdated and in disrepair, was replaced by a two-phase, $5.3 million Winnebago County Courthouse and jail complex built between 1967 and 1972, including a 10-story courthouse tower anchoring West State and South Church Streets. The old courthouse was razed in 1969–70. A joint city-county Public Safety Building opened at 420 West State in 1977.

RIVER BLUFF NURSING HOME, 4401 NORTH MAIN STREET, 1971. River Bluff Nursing home traces its roots to Winnebago County's 1853 establishment of its "Poor Farm" on the 230-acre John DeGroodt farm. The *c.* 1883 Winnebago County "Almshouse" (bottom left), given over to hospital and nursing home operations in 1884 and expanded in 1920 and 1930, was replaced in 1971 with this sprawling $4.75 million state-of-the-art, 300-bed nursing facility. The county institution, renamed River Bluff in 1956 and switched exclusively to nursing home care in 1957, conducted 160-acre farming operations here as a profit-making venture from 1853–69, ending dairying operations in 1963.

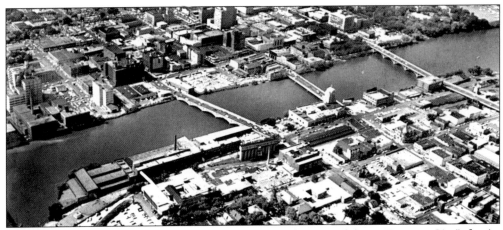

"At the Top" in Illinois. First nicknamed "Midway" and later "Reaper City" for its burgeoning reaper industry, Rockford has been the "Forest City" since the mid-1850s, when visiting New York *Tribune* writer Bayard Taylor coined Rockford's longstanding moniker. Contemporary attempts to update Rockford's image have met with varying success. The Chamber of Commerce's timeworn "At the Top in Illinois" was unveiled in 1957. America's "Furniture City" in the 1920s, Rockford from the 1950s-80s was billed as the world's "Metal Fastener Capital" and "Screw Capital." More recent attempts include the Convention & Visitors Bureau's "Illinois' Second City" promotion in the 1980s, the Chamber of Commerce's "Real America" in 1986–87, and morale boosting "Rockford: A Different Kind of Greatness" in 1996–97. But none of the upstarts has had the staying power of Rockford's enduring and beloved "Forest City" designation. (Photo: Herzog Photographers)

ELECT
EUGENE R. QUINN
REPUBLICAN
COUNTY RECORDER

"I BELIEVE MY ADMINISTRATIVE BACKGROUND HAS PREPARED ME TO EFFICIENTLY OPERATE THIS OFFICE"

Eugene R. Quinn for County Recorder of Deeds, 1972. Republican Eugene "Gene" Quinn was a popular local veteran politician during his 1968–96 career. A City of Rockford administrative assistant under Mayor Ben Schleicher, Quinn later served 19 years as county recorder. From 1993–96, Quinn served as the first full-time, popularly-elected chairman of the 28-member Winnebago County Board. Leading a successful grass roots 1983 campaign to end "home rule," Rockford's ability to raise taxes without voter consent, Quinn ran an aggressive 1985 Rockford mayoral election campaign against incumbent Democrat John McNamara (1981–89), who had opposed the change. McNamara narrowly beat the popular Republican by just 179 votes. (Courtesy: Mathew J. Spinello)

Three
HOTELS AND
RESTAURANTS

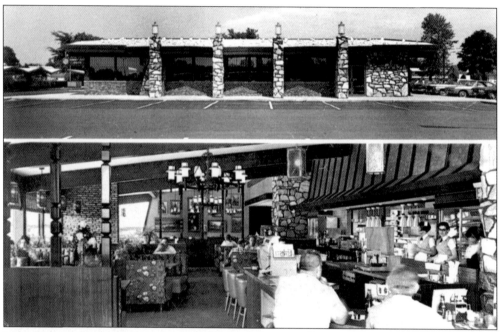

HOLLYWOOD DINING CENTRE, 5303 NORTH SECOND STREET, 1968. Founded by Carl Voraiko, Hollywood Drive-In and its dine-in successor, Hollywood Dining Centre, would become a Rockford institution under Joseph Engebretson's 1954–92 ownership. Capitalizing on the 1950s and 1960s drive-in craze with his trademarked Oscar and double-decker Hi-Boy hamburgers, fresh strawberry pie, and Golden Skillet fried chicken, Engebretson built Tinseltown-themed Hollywood (1952–1993) into a regional empire of 14 stateline eateries by the early 1970s. In 1965, Engebretson tapped leading U.S. restaurant architect Robert Burton to convert several drive-ins into Hollywood Dining Centres, an industry pioneer that combined sit down, carry out, and curbside dining. This $400,000 suburban Loves Park Hollywood Dining Centre opened in 1968. Curbside service ended in 1975. Facing increased competition, changing customer tastes, and Rockford's 1980s "Second Depression," Hollywood slowly retrenched. This Loves Park Hollywood, the chain's last vestige, was sold to the national Denny's chain in 1993. (Photo: Latimer Studio)

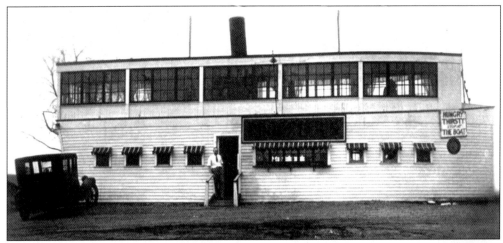

THE BOAT DRIVE IN, 4057 WEST STATE STREET, 1932. In the early decades of the automotive era, restaurants, motels, and gas stations often used kitschy roadside architecture to catch the motorist's eye. Catering to west side residents and hungry east-west through travelers on old U.S. 20, Buster A. (pictured) and Irene Ties operated their nautically-themed Boat Drive-In root beer stand from 1932 to 1933. A unique architectural fixture at Springfield Avenue and West State between 1932 and 1959, the structure subsequently housed a Boat "milk depot" in 1934–35 and grocery stores under the Boat and Fair-Way names between 1936–59.

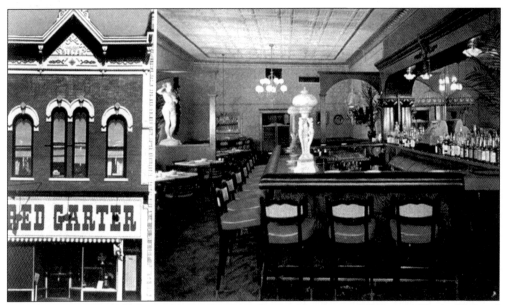

THE RED GARTER, 308 EAST STATE STREET. Located in the *c.* 1879 Pyng's Block, Phil and Bob Salamone's 1890s-styled Red Garter offered daily luncheons and dinners, cocktails, and nightly entertainment. During its 1958–62 run, the Red Garter was one of 18 bars and restaurants located in a 10-block downtown stretch of East State. Now home to around a dozen bars and restaurants, the area today includes a number of widely-popular trendy establishments, including the Irish Rose Saloon, Bacchus Wine Bar & Restaurant, and the Carlyle Brewing Co. brewpub. Later home to the Flamingo Club, Pyng's Block has been anchored by Schleicher Printing since the late 1980s. (Photo: Henry Brueckner)

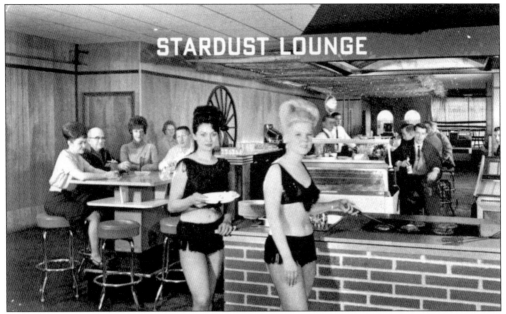

STARDUST LOUNGE, 1436 NORTH MAIN STREET. Located in Rockford's North Main and Auburn retailing district, the steaks weren't the only sizzle at Ronald J. Minnehan's Stardust A-Go-Go Lounge (1964–73), where bouffant-coifed, bikini-clad waitresses attended to customers sipping colorful cocktails and longneck bottles of Schlitz. Live entertainment and dancing were offered nightly at Stardust, today home to Leisure Tyme Billiards & Sports Bar. Today slowly experiencing renewal as "North End Commons," development of Rockford's North Main and Auburn business district began in the Roaring Twenties and resumed again in the post-Depression, post-World War II years as northwest Rockford's residential development accelerated.

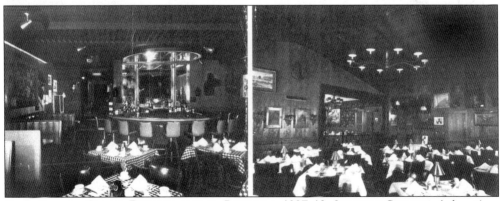

SADDLE AND CYCLE RESTAURANT & LOUNGE, 1307-13 AUBURN STREET. A longtime anchor of Rockford's North Main and Auburn retail district, Saddle and Cycle was famed for its steaks, seafood, and barbecue ribs, feted as "the Mid-West's most exquisite dining room." Opened in 1935 by brothers Jay "Jake" and Joseph "Joe" Rotello, Saddle and Cycle operated until its sale by Jay Rotello in 1977, two years after Joe Rotello's death. Subsequently operated as Bianarro's Supper Club by brothers-in-law Bob Bianachi and Wayne Tarro, the restaurant more recently has housed Trattoria Fantini and today's newly-opened Table 13. (Photo: Jay Rotello; Courtesy: Mary Lou Liebich Yankaitis)

MANDARIN GARDENS RESTAURANT, 121 NORTH WYMAN STREET. Ethnic Chinese cuisine has long been a Rockford favorite. Mandarin Gardens traced its roots to Rockford's first Chinese restaurant, King Joy Lo Chop House, opened in 1919 at 118 West State as the first Rockford restaurant venture of American-born Wong S. Tong. Later, with the assistance of his wife Sophie, Tong opened Mandarin Gardens at 124 West State, relocating to this Wyman Street location in 1939. Employing an American melting pot of Chinese, Irish, Mexican, Italian, and Swedish employees, Mandarin Gardens was a consistently popular downtown restaurant until its 1975 closure at the hands of urban renewal.

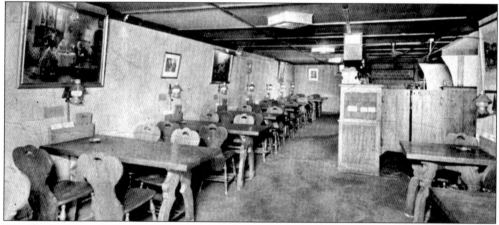

THE SAUSAGE SHOP AND DER RATHSKELLER RESTAURANT, 1132 AUBURN STREET. One of Rockford's oldest restaurants, Der Rathskeller, was opened by German-American Milwaukeean Fred Goetz in the North Main and Auburn shopping district in 1931. Originally a retail cheese and sausage shop, Prohibition's 1933 repeal saw Goetz add beers, wines, and liquors. Carryout customers soon began asking Goetz for sandwiches and the German cuisine Der Rathskeller was born in the Sausage Shop's basement. Patterned after the University of Wisconsin-Madison's famed Rathskeller, Der Rathskeller achieved national recognition with its inclusion in restaurant critic Duncan Hines' famed *Adventures in Good Eating* dining guide. Though Goetz retired in 1978, Der Rathskeller remains a popular Rockford dining destination under his longtime successors—the mother and son ownership team of Betty Awes and Mike DuPre.

REDWOOD RESTAURANT, 307 SOUTH MAIN STREET. A longtime coffee shop fixture in downtown's Beaux Arts-styled *c.* 1911 R&S Building, the Redwood opened in 1920 as the White Dove. Purchased in 1931 by immigrant Greek restaurateur Samuel P. Stavros, the longtime operator of the nearby Illinois Hotel's popular Illinois Café, Stavros' renamed Main Restaurant became the Redwood following a 1953 remodeling. Stavros, 80, sold Redwood upon his 1968 retirement. A longstanding Stavros tradition were the free wartime breakfasts given to soldiers heading off to duty during World War II, Korea, and Vietnam. In 1991, the Redwood and the R&S Building were sold to Sam and Linda Pirrello, who extensively remodeled the building and restaurant as Sammy's Restaurant and Bakery.

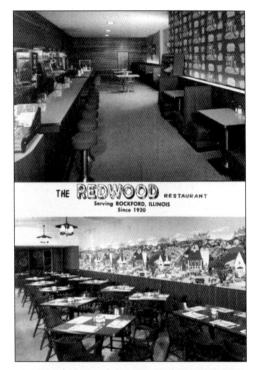

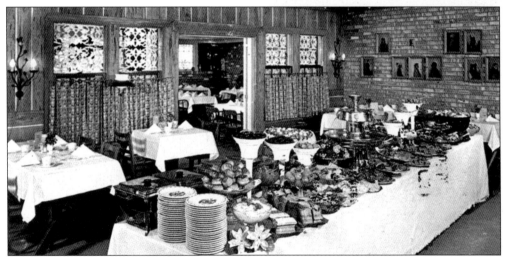

SWEDEN HOUSE, 4615 EAST STATE STREET. Famed for its Swedish cuisine and vast smorgasbord, Sweden House opened on Seventh Street in 1921 as Eklund's Cafe. Founded by brothers Axel A. Eklund Sr. and Arthur Eklund, and their culinarily-accomplished wives, including Axel's wife Hildur, operations later included son Axel F. Eklund Jr. and his wife Mildred. Outgrowing their central city quarters, the Eklunds relocated their Sweden House to an outlying U.S. 20 farmhouse in 1942. Operations would eventually include a "stuga" party room, gift shop, and hotel. Sold in 1977 to Rockford's Fridh Corp., the restaurant later closed, and the site was redeveloped in the late 1980's for National City Bank. Once the only restaurant east of the Faust Hotel, by 1970 Sweden House was one of 40 restaurants as Rockford pushed east toward I-90. (Photo: Henry Brueckner)

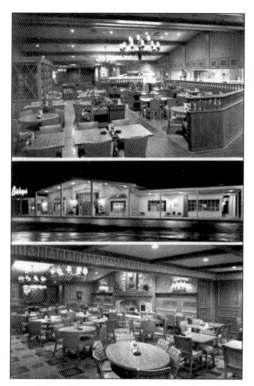

BISHOP'S BUFFET, 4230 NEWBURG ROAD, 1967. In the 1950s and 1960s, newly-developed outlying shopping centers began siphoning business from Rockford's downtown, Seventh Street, and Broadway business districts. Anchored by supermarket A&P, Rockford-based Charles V. Weise Co. (Bergner's), and national department stores W.T. Grant Co. and JCPenney, *c.* 1964 Colonial Village Mall spurred the 1967 relocation of downtown's popular Bishop's Cafeteria, a fixture since 1929 at 210 North Main. As dining preferences later shifted from cafeteria-styled restaurants, the Iowa-based Bishop's chain retrenched, abruptly closing its Rockford restaurant in 1997. Bishop's now houses SwedishAmerican Health Systems' Midwest Center for Health and Healing.

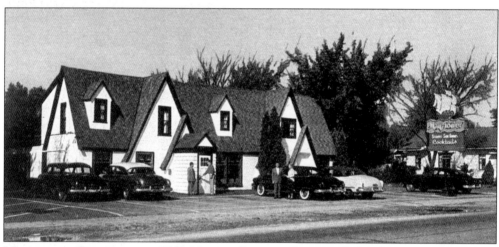

MAYFLOWER RESTAURANT, 5040 NORTH SECOND STREET. Del White's popular *c.* 1933 Mayflower in suburban Loves Park long reigned as the area's premiere restaurant for dinners, banquets, and business and political "power lunches," particularly under the longtime ownership of popular restaurateur Tony Salamone. Serving fresh-cut steaks and seafood, a Mayflower house specialty was its famed Bookbinder Soup, a seafood gumbo patterned after the original turtle soup served in Philadelphia's popular Bookbinder Restaurant. The Mayflower, under new ownership and management, closed in 1999. Extensively remodeled, the idled restaurant briefly operated as LaMere's Mayflower Steak & Seafood from 1999–2001. The old line Rockford restaurant reopened as "Morning Glory at the Mayflower" in 2002. (Photo: Henry Brueckner; Courtesy: Mark D. Fry)

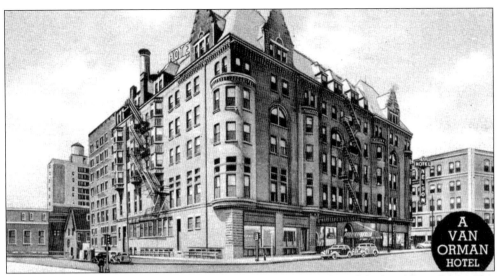

NELSON HOTEL, 306 SOUTH MAIN STREET, 1938. One of Rockford's oldest and leading hotels, the popular Nelson (1892–1959) was "famed for its warm spirit of hospitality and…the excellence of its food and service." In 1917–19, the 165-room Nelson built a $400,000, seven-story "Annex," adding 200 rooms. Beyond its sheer size and modern amenities, the Nelson's reputation was further enhanced by its popular restaurants and mezzanine Crystal Room, decorated in fuchsia, chartreuse, and "Swedish gray." Though eclipsed by the Art Deco Hotel Faust in 1930, the Nelson kept up with changing times, switching to the popular "European Plan," remodeling, and adding its famed Jade Ballroom. Sold to Fort Wayne-based Van Orman Hotels in 1934, the Nelson was sold to a Chicago syndicate in 1943 and to National Chain Hotels in 1949. Purchased by the City of Rockford for downtown urban renewal, the Nelson was demolished in 1960–61. At the time of this postcard, nightly room rates started at $1.75.

NELSON HOTEL & ANNEX, 306 SOUTH MAIN STREET. Had things gone differently, the grand dame "red carpet" Nelson Hotel might still be anchoring the southeast corner of South Main and Chestnut. Ranked among Rockford's "finest" hotels, the Nelson's 1958 plans called for demolition of its *c.* 1892 hotel building (left) in preparation for the construction of a state-of-the-art 100-room addition to its *c.* 1919 "Annex" (right), which was extensively remodeled in 1944 and 1953. Ultimately, the City of Rockford purchased the Nelson, razing the hotel in 1960–61 as one of downtown's inaugural urban renewal projects. First replaced with a surface parking lot, a 284-car parking deck was built in 1968. In March 2004, plans were unveiled to raze the deck for surface parking.

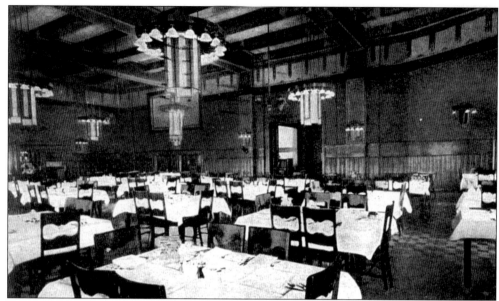

NELSON HOTEL DINING ROOM. In the days before discount-oriented national chain lodging was pioneered in the 1950s, landmark full-service "red carpet" downtown hotels had largely dominated the nation's motel business. Grand dame downtown hotels like Rockford's Hotel Faust and Nelson Hotel, mirroring their counterparts in other U.S. cities, took a great measure of pride in many aspects of their unique hospitality operations, including their signature restaurants. Pictured here is the Nelson's opulent dining room as it appeared shortly after the end of World War I. (Courtesy: Mark D. Fry)

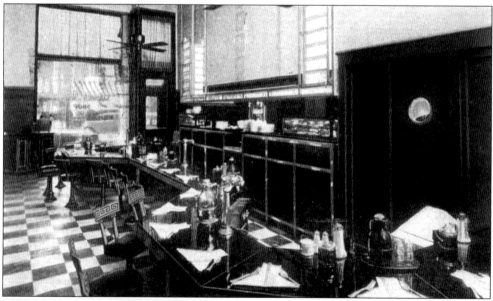

NELSON HOTEL SANDWICH AND WAFFLE SHOP, 1930. Hurried and budget-minded travelers, as well as hungry local residents, could count on a quick and inexpensive, but nevertheless satisfying meal in the Art Deco surroundings of the Nelson's cozy lunch counter "Sandwich and Waffle Shop." (Courtesy: Mark D. Fry)

46

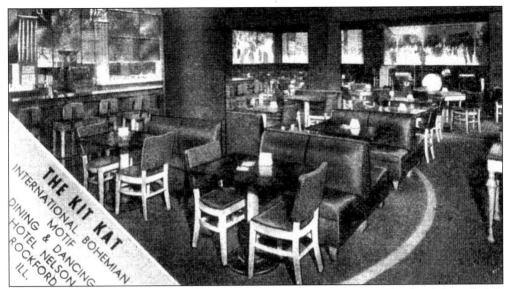

THE KIT KAT, NELSON HOTEL. In cities nationwide, major downtown grand dame hotels often offered a city's most cosmopolitan and avant-garde dining and entertainment experiences. In Rockford, an international experience could be had by visiting the Nelson Hotel's "Kit Kat," which offered travelers and local residents alike the opportunity to indulge in the trendy pleasures of "international Bohemian motif dining and dancing." (Courtesy: Mark D. Fry)

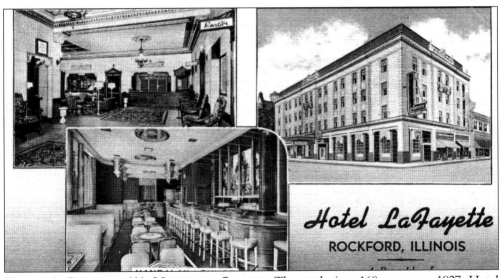

HOTEL LAFAYETTE, 411 MULBERRY STREET. The enduring 160-room, *c.* 1927 Hotel LaFayette was one of the first major projects of prolific Rockford developer Max Liebling (1893–1972), a 1910 immigrant Austrian Jew who would build downtown's Nu-State, Canfield Clinic, Times Theater, IBM, and Mendelssohn Club buildings, in addition to outlying developments including the Rural Oaks Shopping Center, Rockford Jewish Community Center, Auburn Theater, Albert Pick Motel, and Clock Tower Resort. Designed by architect Edward Paul Lewin, the $250,000 Spanish-styled hotel was named after the Marquis de LaFayette and is today billed as "the last of Rockford's old red carpet hotels." Popular activist first lady Eleanor Roosevelt (1884–1962) is among the LaFayette's elite guests, visiting in 1937.

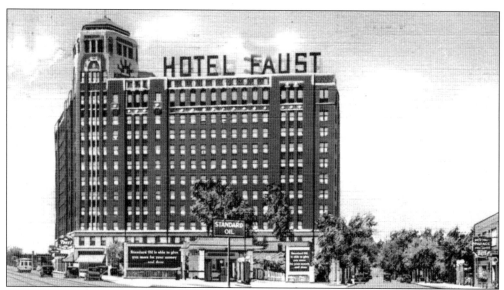

HOTEL FAUST, 618-32 EAST STATE STREET, 1936. One of Rockford's best-known architectural landmarks, Midway Hotel Corporation's $2.75 million Art Deco Hotel Faust was built in 1928–30. Rockford industrialist Levin Faust, an immigrant Swede, invested and lost his "American Dream" fortune in the 400-room, 36-apartment hotel. Designed by Chicago architect Eric Hall, the hotel's two eleven-story wings were anchored by a signature 14-story center tower housing an observation parapet, water reservoir, and the Faust's Grand and Junior ballrooms. In Depression-fueled bankruptcy by 1933, the Faust went through a succession of owners, experiencing its best years in the late 1940s and 1950s under the ownership of Wisconsin auto dealer and hotel owner Arthur Dufenhorst.

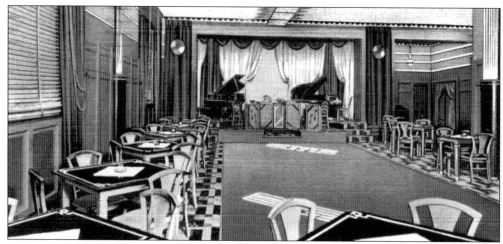

HOTEL FAUST—RAINBO ROOM, 1936. One of Rockford's most colorful post-Prohibition spots for cosmopolitan nightlife was the Hotel Faust's popular Rainbo Room. Advertised as the "most beautiful night club and cocktail lounge in the Middle West," the dine-and-dance Rainbo Room was host to a parade of local, regional, and national big band and jazz performers in its 1930s and 1940s heydays. Writing to the "folks" back home in California, "Edna & Mark" sent this postcard near the end of their stay at the Faust, during Mark's Rainbo Room show engagement.

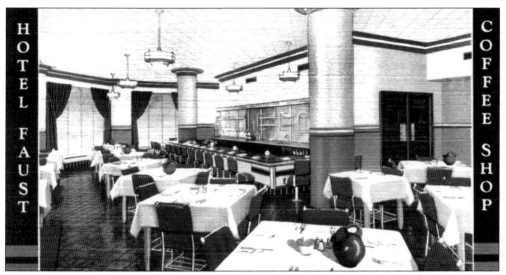

HOTEL FAUST COFFEE SHOP, 1938. Developed at a cost of $50,000 in 1938, the Faust's new air-conditioned coffee shop was billed as "completely modern throughout" and "expected to become one of the most popular downtown restaurants." The Art Deco-styled coffee shop, designed by Texas architect Anthony Frazier, featured a harmonizing yellow, red, and blue color scheme, indirect lighting, back bar and counters of stainless steel, natural maple finish tables, and aluminum-construction chairs and counter stools. The Faust's new 170-patron coffee shop was part of over $100,000 in improvements and renovations by Affiliated National Hotel Co., which had assumed management of the Faust in 1937.

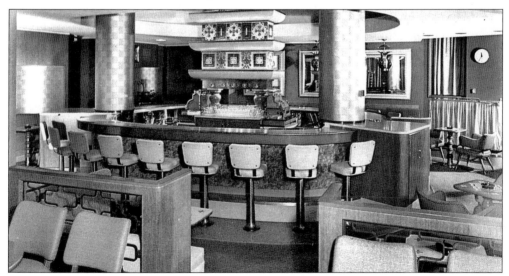

HOTEL FAUST—TERRACE LOUNGE. In the pre-1960s golden age of downtowns and their full-service grand dame hotels, leading hospitality properties like the Faust brought guests and local residents alike a taste of the exotic with their lavishly-decorated bars and restaurants. Billed as "the Midwest's most unique cocktail room," the Hotel Faust's Terrace Lounge offered this "world of Persian splendor . . . for relaxation and entertainment." Development of the Terrace Room was part of owner Arthur Dufenhorst's $1.2 million upgrade of the Faust in 1947–53. (Photo: Henry Brueckner)

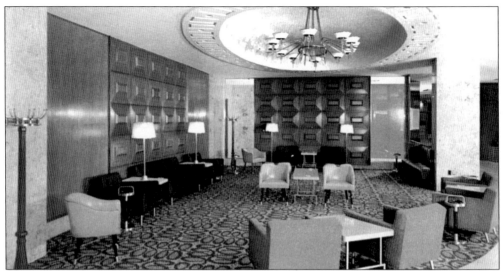

HOTEL FAUST—LOBBY LOUNGE. Opened as an Art Deco-styled hotel in 1930, changing styles and tastes spurred hotel owner Arthur Dufenhorst's $1.2 million, 1947–53 interior and exterior "modernization," which included the new Lobby Lounge as seen here. The Hotel Faust's most active years ran until the early 1960s, years when the hotel was a center of Rockford social life and home to political rallies, social events, top-name bands, and notable guests, including future U.S. presidents John F. Kennedy and Richard M. Nixon. (Photo: Henry Brueckner)

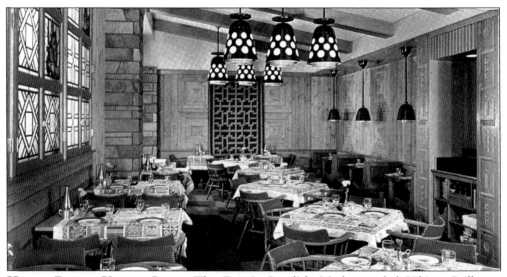

HOTEL FAUST—VIKING GRILL. The Faust's Swedish Modern-styled Viking Grill was "exquisitely done with every thought in your dining pleasure." The Faust was named in honor of hotel capitalist Levin Faust (1863–1936), a leading Rockford immigrant Swedish businessman, entrepreneur, and philanthropist. Founder of Mechanics Universal Joint Co. and National Lock Co., Faust also helped organize Sundstrand, Rockford Drop Forge, Elco, and Estwing. Active in the community, Faust was a member of the Svea Soner singing society and a founding commissioner and 27-year board member of the *c.* 1909 Rockford Park District. Though financially ruined by the Depression and his hotel investment, Faust served as chairman of Rockford's National Recovery Act board.

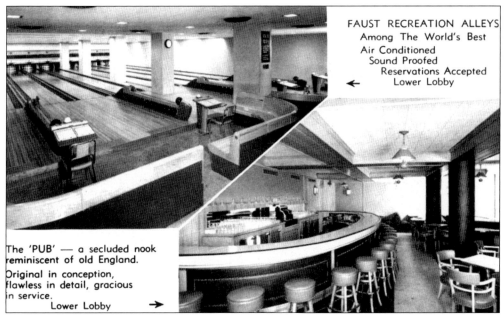

FAUST RECREATION ALLEYS
Among The World's Best
Air Conditioned
Sound Proofed
Reservations Accepted
← Lower Lobby

The 'PUB' — a secluded nook reminiscent of old England.
Original in conception, flawless in detail, gracious in service.
Lower Lobby →

HOTEL FAUST—RECREATION ALLEYS AND THE PUB. Billed as "Rockford's finest" hotel, the 400-room Faust offered its guests a number of recreational, entertainment, and hospitality amenities. "Lower Lobby" facilities included the modern, automated Faust Recreation Alleys (upper left), said to be among the "world's best" bowling alleys, and the "Pub" tavern, billed as "a secluded nook reminiscent of old England" that was "original in conception, flawless in detail, gracious in service." Addition of the Faust Recreation Alleys was part of the six-year, $1.2 million redevelopment of the Hotel Faust by owner Arthur Dufenhorst between 1947 and 1953.

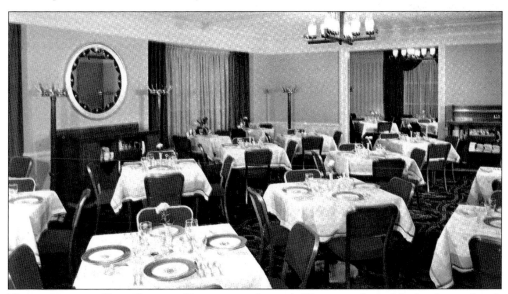

HOTEL FAUST—OLD COLONY ROOM AND ANNEX. Heavy on the golds, ivories, and reds with linen tablecloths and finely-decorated china, the Faust's "new . . . exquisitely done," Colonial-styled Old Colony dining room and adjacent Annex (right) was said to offer its patrons "the ultimate in gracious dining."

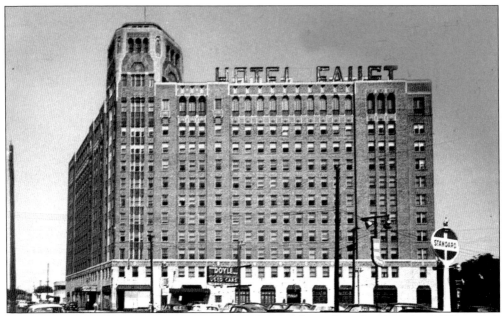

HOTEL FAUST, 618-32 EAST STATE STREET, 1957. After a short-lived 1940s–1950s revival, the Faust declined after outlying I-90 and U.S. Bypass 20 diverted downtown's U.S. 51 and U.S. 20 through traffic. Longtime owner Arthur Dufenhorst sold the "white elephant" Faust in 1971. By 1973, new owners Donald and Dale Levinson were in bankruptcy and the hotel was auctioned to Rockford's Tebala Shriners. In 1986, Tebala sold its renamed Tebala Towers to Faust Landmark Partnership, which redeveloped the hotel as Faust Landmark, a 200-apartment complex for the elderly and disabled. The Faust's *c.* 1929 sign, marked by 14-foot-high red neon letters, anchored the Rockford skyline until 1974. (Photo: Jack Taylor)

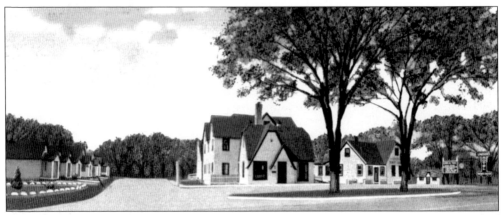

LARSON'S MOTEL, 3303 EAST STATE STREET, 1953. Before the advent and fast spread of national chain motels, roadside lodging meant staying at one of the thousands of "mom-and-pop" cottage-styled tourist court motor hotels or "motels" that lined U.S. highways during their 1920s–1950s heydays. An "X" marks the spot where vacationing Bertha and Gordon spent the night in Rockford at the 23-unit Larson's Motel (1940–63). Changing consumer preferences for new national chain motels and the construction of high-speed, limited access highways like Bypass U.S. 20 and I-90 doomed tourist courts like Larson's. The 179-unit, 13-story Valley View Apartments elderly housing development was built on this site in 1973–75.

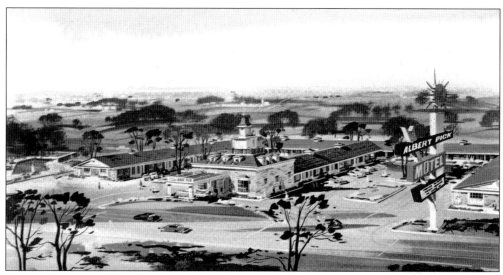

ALBERT PICK MOTEL, 4404 EAST STATE STREET, 1961. Opened along old U.S. 20 in 1959 as the Edge O' Town Motel, days when nearby East State and Alpine Road was literally the "edge o' town," this enduring 110-room hospitality development affiliated with the Chicago-based national Albert Pick Hotel Corp. chain in 1961. In 1972, Pick sold this property to Rockford's Eklund family, operators of the nearby Sweden House Lodge. The Rockford hotel continued to operate under the well-known Pick name until 1984, when Rockford-based Fridh Corp., successors to the Eklund family hospitality empire, took the hotel independent as Alpine Inn. In 1999, Alpine Inn was renamed Villager Lodge as a franchisee of New Jersey-based Villager.

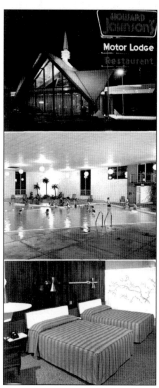

HOWARD JOHNSON'S MOTOR LODGE & RESTAURANT, 3909-19 ELEVENTH STREET, 1966. Among the first national hospitality chains to stake a Rockford claim was Massachusetts-based Howard Johnson Co. (*c.* 1925), the nation's orange-roofed "Host of the Highways." Following the 1962 completion of Bypass U.S. 20 just south of Rockford, "Ho Jo's" broke ground in 1963 for this $1 million development encompassing an 84-room motor lodge and adjoining 150-seat restaurant. Major expansions were completed in 1966 and 1971. Dropping the Howard Johnson franchise in 2004, the hotel now operates independently as Rockford Inn. The adjacent Howard Johnson's Restaurant has been operated by a succession of independent operators under a variety of names since the 1970s. At its mid-1960s height, Howard Johnson's also operated stand-alone restaurants on East State Street in Rockford and North Second Street in Loves Park.

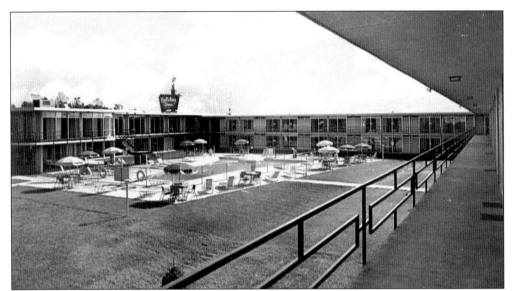

HOLIDAY INN, 4419 ELEVENTH STREET. In the 1960s, proximity to Greater Rockford Airport and the newly-completed U.S. Bypass 20 turned Eleventh Street, then U.S. 51, into a motel row anchored by national chains including Motel 6, Regal 8, Howard Johnson's, and Memphis-based Holiday Inn, which operated this 152-room hotel from 1961–83. This motel, later franchised as Quality Inn, Comfort Inn, and Days Inn, today operates independently as Airport Inn. Rockford, subsequently one of the biggest U.S. markets without a Holiday Inn, gained a new Holiday Inn in 1995 when the seven-story, *c.* 1974 202-room Ramada at 7550 East State switched affiliation.

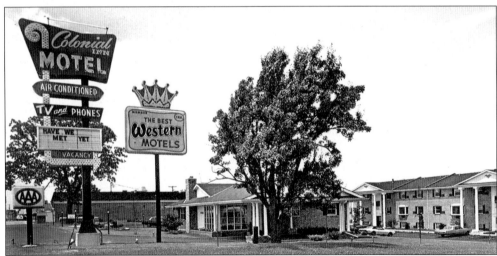

COLONIAL INN MOTOR LODGE, 4850 EAST STATE STREET. The 1964 relocation of downtown's Rockford College to its new outlying east-side campus near the I-90 Northwest Tollway spurred the greenfield development of complimentary businesses, including the nearby Colonial Inn Motor Lodge. An affiliate of Best Western, the 60-room Colonial Inn opened in 1966. The hotel grew into a 93-room facility before a 1992 natural gas explosion leveled an entire hotel wing in a spectacular blaze. Colonial Inn later reopened as an 84-room facility. (Photo: Latimer Studio)

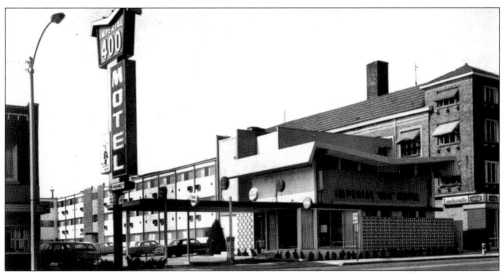

IMPERIAL 400 MOTEL, 733 EAST STATE STREET. The nation's "motor lodge" era of the car-crazed 1950s and 1960s was still in full swing when Rockford's 69-unit Imperial 400 Motel opened in 1964 as part of a short-lived downtown hotel building boom in the mid-to-late 1960s. Opened by Edward A. and Grade Tintera as an affiliate of the coast-to-coast Imperial 400 partnership chain, the AAA-approved hotel offered a heated swimming pool, king-size beds, in-room TV's and telephones, free coffee, and individually-controlled heat and air conditioning. Today operating as the Inn Town Motel, the property has declined in stature in recent decades.

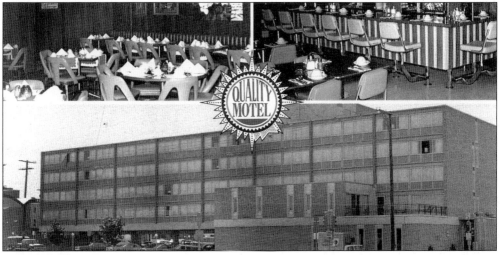

QUALITY MOTEL MIDTOWN, 1055 EAST STATE STREET. By the 1960s, outlying I-90 and U.S. 20 Bypass had all but killed downtown's hotel industry by siphoning business to new interchange hotel developments. National Motor Inn's $1.25 million, 115-room motel (1969–78), later Quality Motel-Midtown, was a major component of the city's "Rockford 1975" downtown revitalization program. Quality-Midtown offered travelers "handsomely appointed rooms and suites," a heated rooftop pool, and a popular Speakeasy-themed restaurant/lounge—*Bonnie Sent Me*. Later transformed into the Al-Care and Evergreen Recovery Center addiction treatment facilities, Zion Development Corp. in the late 1990s redeveloped the property into its Longwood Manor Apartments for low-income seniors.

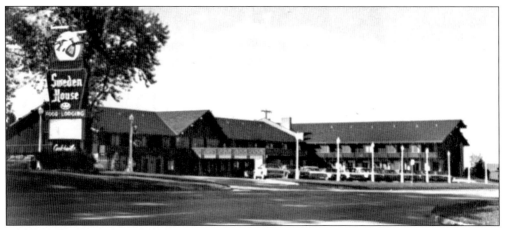

SWEDEN HOUSE LODGE, 4605 EAST STATE STREET, 1973. In 1965, the Eklund family's popular Business U.S. 20 hospitality operations expanded to include the enduring Sweden House Lodge, a 67-room "ultra modern lodge of Swedish architecture featuring a beautiful blend of woods and stone by Swedish tradesmen." By the time of this postcard, Sweden House had expanded to 107 guest rooms. The 1974 death of Axel Eklund Jr. in an automobile accident saw Sweden House Lodge sold to Rockford's Fridh family, which bought the Eklund family's adjacent and since-redeveloped Sweden House restaurant in 1977. (Photo: Carlson Commercial Photography)

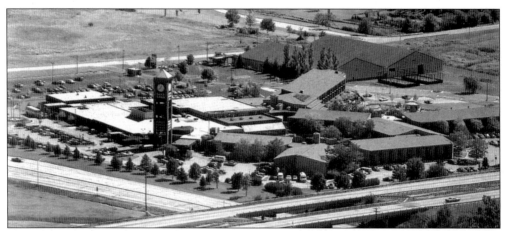

CLOCK TOWER RESORT AND CONFERENCE CENTER, 7801 EAST STATE STREET. Built by prolific Rockford developers Max and Alva Liebling at Rockford's busy I-90 and East State Street interchange, the popular Clock Tower, long owned by Rockford's Atwood family (1969–99), began its history in 1968 as Henrici's, a $1.8 million 13-acre complex encompassing a 120-room motel and 216-seat restaurant. Designed by Chicago's Loebel, Schlossman, Bennet & Dart, Henrici's was renamed Clock Tower in 1970 after Rockford businessman Seth Atwood moved his world-renowned 1,600-piece horology collection to the hotel and opened his famed Time Museum. The hotel's signature 100-foot tall clock tower was added in 1973. Sold to South Dakota-based Regency Hotel Management in 1999, Best Western-affiliated Clock Tower today encompasses 26 acres and 253 guest rooms. Notable guests include presidents Gerald Ford and George H.W. Bush, comedians George Burns and Red Skelton, musicians Kenny Rogers and The Beach Boys, and sports stars including the Harlem Globetrotters, Bjorn Borg, and Billie Jean King.

Four
BUSINESS AND INDUSTRY

ROCKFORD NEHI BOTTLING CO., 2700 NORTH MAIN STREET. This newly opened, 20,000-square-foot Art Moderne-styled soft drink bottling and distribution facility was feted to be "modern in every respect." An addition to house a new high-speed bottling line was built in 1972, years when Rockford Nehi-RC bottled and canned Royal Crown (RC), Diet Rite Cola, RC's fruity Nehi sodas, Upper 10, Dad's Root Beer, and Canada Dry Ginger Ale for a 10-county distribution area in northern Illinois and southern Wisconsin. Later a division of Florida-based All-American Bottling Corp., this Rockford Royal Crown Cola Co. facility was one of nine U.S. bottling plants operated by All-American in the mid-1980s. The firm, today operating as Dr. Pepper/Seven Up Bottling Group, relocated to suburban Loves Park in 1987–88. This northwest side site was redeveloped in the 1990s for a now-shuttered supermarket once operated by Milan-based Eagle (1895–2003). The site, as well as surrounding commercial and industrial properties, awaits reuse.

DEAN MILK CO., 1126 KILBURN AVENUE. Organized in 1929, Rockford Consolidated Dairies Co. opened this Rockford production facility in 1930. Rockford Consolidated Dairies was purchased by Dean in 1931, one of its many Illinois dairy acquisitions in the late 1920s and early 1930s. Founded by Samuel E. Dean Sr. as Dean Evaporated Milk Co. in nearby rural Pecatonica in 1925, Dallas-based Dean Foods Co. today ranks as the nation's largest dairy processor. Dean's expanded Rockford facility today includes a research and development lab and production facilities for cottage cheese and chip dips. Dean operates dairy plants in 34 states, including regional northern Illinois production facilities at Pecatonica, Belvidere, Chemung, Dixon, and Huntley.

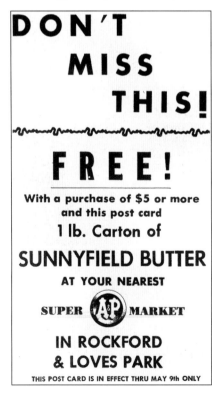

A&P SUPERMARKETS (GREAT ATLANTIC & PACIFIC TEA CO.), 1961. North American supermarket behemoth A&P (*c.* 1859) was in its waning heydays when it issued this coupon postcard for its Rockford and Loves Park stores. Served by A&P wagon delivery routes since the 1880s and by brick-and-mortar A&P supermarkets since 1917, A&P was a longtime Rockford retailing presence. As late as the 1960s, A&P's Chicago Division still dominated the region's grocery business with six Rockford and Loves Park supermarkets, in addition to stores at Belvidere, Freeport, Sterling, Dixon, Rochelle, and Mt. Morris. Faltering badly in the 1970s and early 1980s, A&P drastically pared its 4,500-store store empire and withdrew from much of the country, including Rockford in 1978, Milwaukee in 1979, and Chicago in 1981. (Courtesy: Mathew J. Spinello.)

MASTERS SHOE COMPANY

SHOES FOR THE WHOLE FAMILY

OLD LOCATION OF EAST SIDE POST OFFICE

OUR HIGHEST PRICE
$4.90
MANY LESS

NOT CHEAP SHOES BUT GOOD SHOES REASONABLE

421 SEVENTH STREET, ROCKFORD, ILLINOIS.

MASTERS SHOE COMPANY, 421 SEVENTH STREET. Founded in 1921 by Ralph K. Masters, son Edward A. Masters, and brother J.P. Masters, Rockford-based family shoe retailer Masters Shoe Co. was a downtown retailing fixture until its 1988 closure. First operating at 421 Seventh Street (1921–24) and 221 South Main (1924–29), Masters subsequently settled into longtime homes at 114-116 and 118-120 South Main in downtown Rockford's c. 1855 and c. 1853 commercial "Limestones," razed in 1988–90. At the company's height, Masters also operated regional stores in Waukegan, Aurora, Beloit, Joliet, and Elgin. (Courtesy: Mark D. Fry)

JACK EGLER'S JUNIOR BOOT SHOP, 1432 MYOTT AVENUE. A nostalgic memory for many Rockford area Baby Boomers and early Gen-Xers are shoe buying expeditions at Jack Egler Junior Boot Shop (1941–85), long located in Rockford's northwest side North Main and Auburn shopping district. First located downtown at 210 North Church Street, Egler's moved to this Myott Avenue location in 1954. The firm briefly relocated to Edgebrook Center in 1984–85. Long reigning as "Rockford's only children's shoe store," Egler's specialized in "the proper fitting of little feet." Postcard recipients were urged to "return this card for free gift." (Courtesy: Mathew J. Spinello)

MARY DEFAY FASHIONABLE CASUALS, 112 SOUTH MAIN STREET, 1960. The low cost and high quality of colorful chrome postcards made them a popular marketing tool for small Rockford merchants like Mary DeFay Emordeno, shown here inside her since-razed downtown store. During its short 1960–63 run as a ladies, juniors, and teens specialty clothing shop, DeFay's offered a "complete line" of skirts, sweaters, suits, slacks, carcoats, raincoats, blouses, dresses, sportswear, jewelry, and a "fine line" of imported knits and handbags. Founded in 1936, relocated Ruth D. Clark Lingerie succeeded DeFay's at this site until its 1980 move to Edgebrook Center. (Photo: Matranga Studio)

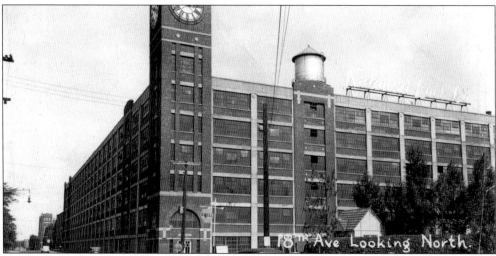

NATIONAL LOCK CO., 1902 SEVENTH STREET. Established in 1903 by Rockford industrialists Levin Faust, Frank G. Hoglund, and Pehr August "P.A." Peterson, National Lock manufactured mortise locks and ancillary hardware for Rockford's once-burgeoning furniture industry. In 1919, "The Lock" built this one-million-square-foot Peterson & Johnson-designed factory as Rockford's largest single industrial plant. Additions were built in 1924 and 1926 and a $5 million, 15-acre fastener plant was opened near Greater Rockford Airport in 1956. Sold to Peoria-based Keystone Steel and Wire in 1939, National Lock employed 3,600 workers in Rockford as late as the early 1970s. Shuttered in the early 1980s when manufacturing operations were moved to South Carolina, National Lock's flagship plant was redeveloped as National Business and Industrial Centre, housing numerous tenants including Rockford Process Control and Anderson Packaging. (Courtesy: Midway Village & Museum Center)

CHARLES V. WEISE CO., 117 WEST STATE STREET. Rockford's Loop was once THE place to be during the Christmas shopping season, as area residents flocked downtown to shop the festively-decorated stores, including Rockford-based department store Charles V. Weise Company. Founded by George D. Bradford and Charles von Weise in 1907, Weise's was sold to Peoria-based P.A. Bergner & Co. in 1954. Operated autonomously, Rockford-based Weise by 1982 had grown into a nine-store, $100 million retailer that ranked as Illinois's largest retailer based outside Cook County. Renamed Bergner-Weise and now operating as Bergner's, the 14-store chain is today operated by Milwaukee's Carson Pirie Scott, a division of Alabama-based national department store retailer Saks Inc. (Courtesy: Mathew J. Spinello)

WILLIAM H. ZIOCK (AMEROCK) BUILDING, 416 SOUTH MAIN STREET. To meet growing demand for its woolen hosiery and socks, Rockford Textile Mills (1881–1955) built this 13-story, reinforced concrete textile factory on its two-acre, five-building downtown campus. Named for late company president William H. Ziock, the $150,000, *c.* 1912 Ziock Building was a towering brick-and-mortar testament to the might of Rockford's pre-Depression textile industry as the world's largest hosiery producer. As Rockford's textile industry declined, other firms, most notably Amerock Corp., overtook use of the Ziock Building. Between 1928–42, Amerock grew to fill the Ziock Building, purchasing the factory in 1949 and building a 6-story, $400,000 addition in 1950–51. Closed by Amerock in the 1990s, downtown enthusiasts hope to transform the long-idled riverfront factory into a loft-style apartment development, offering dramatic views of the Rock and the downtown skyline. (Courtesy: Midway Village & Museum Center)

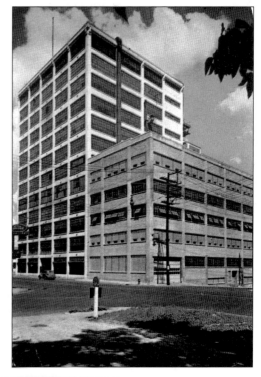

WOODWARD GOVERNOR CO., 5001 NORTH SECOND STREET. Founded in Rockford by N.C. Thompson Reaper Works machinist Amos Walter Woodward in 1870, Woodward parlayed his invention of the world's first mechanical governor into Woodward Governor Co., today the world's oldest and largest manufacturer of prime mover controls. In 1941, the company's headquarters manufacturing facility relocated to this 25-acre site in suburban Loves Park. Woodward today designs, manufactures, and services energy control systems and components for aircraft, industrial engines, and turbines for leading original equipment manufacturers in the power generation, process, transportation, and aerospace industries. The Woodward plant and main-entry drive have long been famed across the stateline area for their lavish Christmas decoration displays.

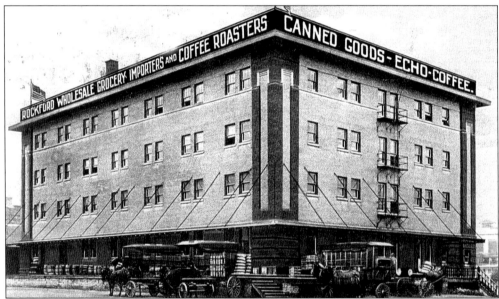

ROCKFORD WHOLESALE GROCERY CO., 216-222 NORTH WATER STREET. Founded by Fred G. Shoudy, Rockford Wholesale Grocery (1887–1952) consolidated its downtown Rockford operations at this nearby riverfront warehouse with its 1936 purchase of competitor Burr Brothers Wholesale Grocers, a wholesale bakery and grocery supplier founded by William J., Charles D. and Frank R. Burr in 1883. Importers and suppliers of general wholesale dry groceries within a 50-mile radius of Rockford, Rockford Wholesale operations also included a roasting plant for the firm's popular *Echo* and *Rockford* coffees. This riverfront warehouse has since been used by a number of commercial users, including Reever's Marina. (Courtesy: Mark D. Fry)

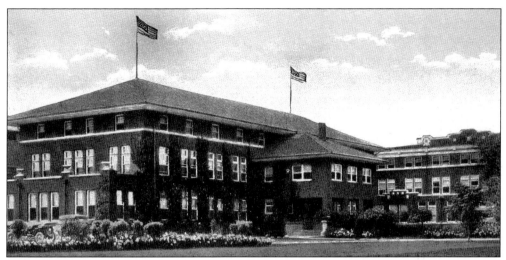

EMERSON-BRANTINGHAM CO. OFFICE BUILDING, 500 SOUTH INDEPENDENCE AVENUE.
Agricultural implement manufacturer Emerson-Brantingham—and its corporate predecessors and successors—was a major Rockford employer from 1852–1970. The company's massive 24-building, 175-acre manufacturing complex was billed as "the most modern and complete farm implement plant in the world." Once an industry high-flyer, Emerson-Brantingham struggled for nearly a decade before its 1928 acquisition by Racine, Wisconsin-based rival J.I. Case Company. Sales declines, driven by a depressed agricultural market, drove Case's 1970 closure of its "Rockford Works." Donated to the City of Rockford, the complex now houses the City Yards and leased commercial space.

FARMING ON A LARGE SCALE—BIG FOUR "30S" PULLING EMERSON ENGINE DISC HARROWS AND EMERSON DRILLS. Employing over 1,800 workers, the influence of agricultural implement manufacturer Emerson-Brantingham Co. (1852–1970) loomed large in Rockford history. In addition to operating its massive west-side manufacturing complex, the company's area operations also included this 250-acre test farm, 10 miles north of Rockford. A prolific early user of postcards, Emerson-Brantingham made extensive use of its test farm as a backdrop for its postcards advertising "the largest line of farm machinery in the world." (Courtesy: Mary Lou Liebich Yankaitis)

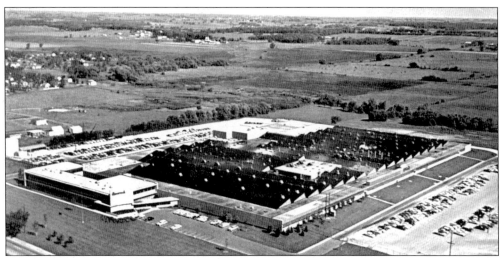

AMEROCK CORP., 4000 AUBURN STREET. Founded in 1928 by five former National Lock Co. employees, headed by Reuben A. Aldeen, American Cabinet Hardware Corp., quickly became North America's leading cabinet hardware manufacturer. Outgrowing its 13-story factory in downtown's Ziock Building, American opened this 450,000-square-foot, 94-acre facility in 1956. The factory, expanded to one million square feet, once housed one of the nation's largest die-casting and stamping operations. Renamed Amerock in 1957, the cabinet, door, and window hardware manufacturer was acquired by Stanley Works in 1966, Anchor Hocking in 1975, and today's Newell-Rubbermaid, Inc. in 1987. Employing 1,200 people in Rockford as late as 1998, Amerock's local workforce has sharply declined since as manufacturing was outsourced or moved to low-wage countries.

R.H. SHUMWAY SEEDSMAN, 1942. Enshrined in the national Seedsmen Hall of Fame, pioneer Rockford seedsman Roland Hallett Shumway (1842–1925) built his enduring *c.* 1870 R.H. Shumway Seed Co. into the world's largest mail-order seed business, famed for its exclusive "Marketmore" seeds. As late as 1968, the company mailed 1.2 million catalogs nationwide, counting entertainers Bing Crosby and Perry Como among its customers. Sold to a South Carolina firm in the early 1980s, use of the enduring Shumway name as a mail order heirloom seed marketer was bought by Wisconsin-based J.W. Jung Seed Co. in the late 1990s.

PIONEER LIFE INSURANCE CO., 1942. Between the 1860s and 2003, Rockford was a major player in the U.S. insurance industry, once home to the regional headquarters of national insurers American and Security, and the hometown headquarters of Rockford Insurance in the 1800s, Rockford Life from 1909 to 1985, and Pioneer Life. Founded in 1926 by Robert W. Nauert, son Peter Nauert built Pioneer into a national power, creating publicly-traded Pioneer Financial Services in 1986. Nauert helped orchestrate Pioneer's $477 million 1997 merger with Indianapolis-based insurer Conseco, Inc., which renamed local operations Conseco Medical Insurance Corp. Following the sale, Pioneer's once-extensive downtown operations—encompassing nearly 600 employees in the National Register-listed Art Deco *c.* 1927 Pioneer Life Building (129 North Wyman), North Main's *c.* 1904 American Insurance Co. Building, and North Main's *c.* 1931 Gas & Electric (PioneerCentre) Building—were massively downsized, eliminated altogether by 2003.

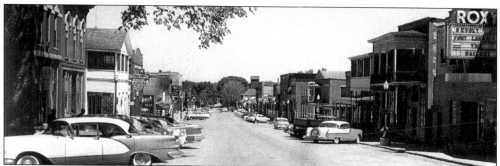

MAIN STREET—PECATONICA, 1964. Capitalizing on its location between Rockford and Freeport, rural Pecatonica (*c.* 1835) carved out a niche as a convenient retailing center serving western Winnebago and eastern Jo Daviess Counties. Founded as Lysander, the village's longstanding Pecatonica designation was drawn from the Indian word for the meandering "crooked river" that skirts the 1,997-resident village. Home to the Winnebago County Fair since 1916, rural Pecatonica later branched out from its agricultural and commercial base with major industrial employers, including Dean Foods and Ipsen Industries. In recent years, Pecatonica's restored downtown has become known for its antiques, art shops, and the *c.* 1991 non-profit Pec Playhouse Theater.

FLOWERS BY CONNIE, 806 NORTH MAIN STREET. Constance Tremulis and her cosmopolitan Flowers by Connie (1957–79) are downtown retailing icons still missed by many. Largely housed in the *c.* 1854 Aaron Marcellus Mansion, Flowers by Connie offered flowers, giftware, collectibles, antiques, and tearoom luncheons. Tremulis built a national following, counting Chicago's P.K. Wrigley family, Nieman-Marcus's Marcus family, and Hollywood horror flick star Vincent Price among her famed customers. Tremulis, an outspoken downtown booster, died in 1977 after an unsuccessful cancer battle. Sold to a Chicago-area industrialist, most of Flowers by Connie was leveled by a massive 1979 arson blaze. The surviving remnant, the Italianate-styled *c.* 1867 Anderson Building, at 803 North Church, is now a historic city landmark. (Courtesy: Mark D. Fry)

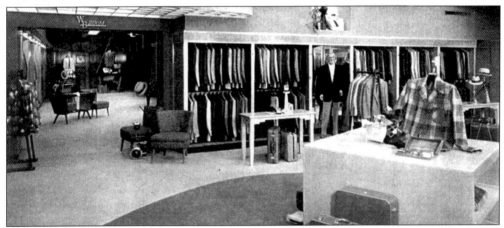

W.B. DORAN INC. MEN'S STORE, 109 NORTH MAIN STREET. Founded by William B. Doran in 1919, Doran's was one of downtown Rockford's premier men's clothiers, carrying prestigious lines including Hickey-Freeman, Hathaway, Pendelton, and Christian Dior. In 1938, Doran's relocated to this longtime Loop location, shown here in its second floor clothing department. Poor health forced William Doran's 1964 closure of his popular store. Later home to Book World, the former Doran store since 1980 has been home to architectural firm David L. Jenkins & Associates, which relocated from suburban Loves Park. (Courtesy: Mathew J. Spinello)

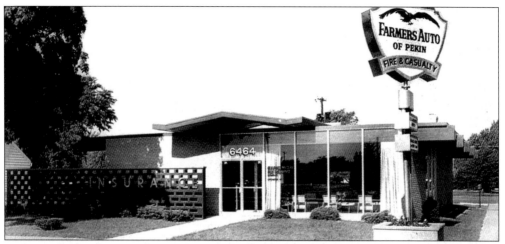

A.W. ANDERSON INSURANCE AGENCY, 6464 NORTH SECOND STREET. As 20,044-resident Loves Park grew following its 1909 founding and 1949 incorporation, a "downtown" commercial district grew along North Second Street. A.W. Anderson Insurance Agency, one of Loves Park's oldest businesses, was founded in 1941 by Harlem High alum Arthur W. Anderson, who opened this facility near bustling Meadowmart Mall in 1960. Buoyed by his business success, World War II veteran Anderson became one of Loves Park's leading citizens and philanthropists, funding local scholarships and the construction of his $650,000, *c.* 1995 *Field of Honor* war memorial. Affectionately known as "Mr. Loves Park," the Harlem High gymnasium and the local history room at Loves Park's North Suburban Library are both named in Anderson's honor.

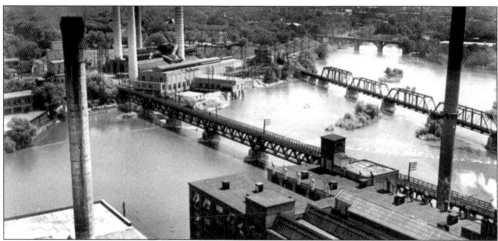

INDUSTRIAL DISTRICT, 1955. Built on Rockford's namesake rock-bottomed river ford in 1853 and rebuilt in 1904–10, the Fordam Dam (middle) long energized Rockford's phenomenal industrial development. Seen at top is Rockford-based Central Illinois Gas & Electric Company's *c.* 1896 Fordam power plant. Idled for hydroelectric generation by the early 1950s, Fordam's coal- and natural gas-fired electric generators continued until 1971. Producing steam heat for downtown buildings until 1973, the Fordam plant was razed in 1974–75. Successor Commonwealth Edison rebuilt Fordam Dam in 1977 to maintain upstream water elevation north to Riverside Boulevard for recreational boating and flood control. (Photo: Jack Taylor)

CAMERA CRAFT, 114 WEST STATE STREET, 1955. Founded by Guy Bingham in 1930, Camera Craft in the 1940s moved to this high-traffic, neon-fronted West State location, surrounded by popular stores including Hickey's Restaurant, Owen's Clothing, Charles V. Weise Co., and the State Theater. Downtown urban renewal forced several relocations—in 1972 to 311 West State, in 1984 to the Columbia Building at 116 South Church, and in 1992 to a consolidated outlying location at Edgebrook Center (1643 North Alpine Road). Camera Craft, later owned by Bill Howell, was sold to Camera Craft salesman Bob D. Brady in 1965. Son Tom Brady assumed operations in 1996. (Courtesy: Mathew J. Spinello)

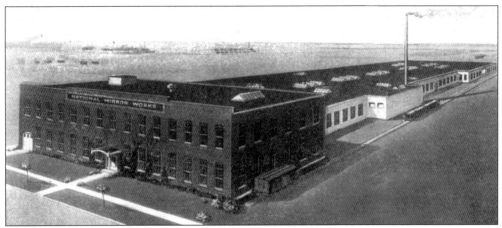

NATIONAL MIRROR WORKS, 1925 KISHWAUKEE STREET. The nation's second-largest furniture producer prior to the Depression, Rockford was also home to numerous furniture industry suppliers and complementary manufacturers, including producers of varnishes, mortise locks, cabinet hardware, glass products, pianos, and grandfather clocks. National Mirror Works, founded in 1896 as a mirror and glass supplier to the city's furniture industry, was once a major southeast-side employer. In 1920, 200-employee National built this plant to produce "everything in glass" from mirrors to complete glass storefronts. Relocated to Beloit as today's National Glass Solutions between 1976–78, National's 44,000-square-foot Rockford facility now houses hot dip galvanizer Rogers Brothers Inc. (Courtesy: Mark D. Fry)

Five
TRANSPORTATION

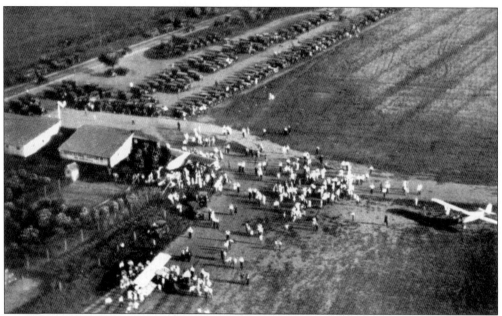

ROCKFORD AIRPORT, 8600 NORTH SECOND STREET, 1931. Despite early 1910s flight exhibitions by famed aviators Beckwith Havens and Jimmy Ward, and the World War I establishment of an Army Air Corps unit at Camp Grant, Rockford aviation wouldn't take off until the 1927 arrival of pioneer barnstorming aviator Fred E. Machesney, widely regarded as the father of Rockford aviation and an inductee into the National Aviation Pioneers Hall of Fame. In 1928, the Rockford Chamber of Commerce developed its 160-acre Rockford Airport (1928–74) on the old William H. Ziock Sr. farm, placing its operations—and in 1943, ownership—in the hands of the intrepid young Machesney, who later renamed the facility Machesney Airport. Other small private area airports included Cherry Valley's old Franklyn Field and the enduring Cottonwood Airport, at 5105 Auburn Street. In August 1928, the fledgling facility would make history as the starting point for the ill-fated Rockford-Stockholm flight of Bert R.J. "Fish" Hassell's *Greater Rockford*. Though the flight fell short of its goal, the *Greater Rockford* flight was nevertheless successful, pioneering the North America-Europe "Great Circle Route" now routinely flown by commercial airliners.

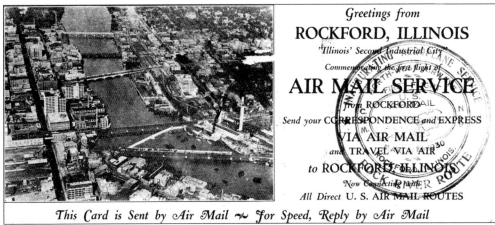

Greetings from
ROCKFORD, ILLINOIS
'Illinois' Second Industrial City'
Commemorating the first flight of
AIR MAIL SERVICE
from ROCKFORD
Send your CORRESPONDENCE and EXPRESS
VIA AIR MAIL
and TRAVEL VIA AIR
to ROCKFORD, ILLINOIS
Now Connecting with
All Direct U. S. AIR MAIL ROUTES

This Card is Sent by Air Mail ～ for Speed, Reply by Air Mail

FIRST AIR MAIL FLIGHT, MARCH 7, 1930. Rockford held a gala celebration to mark its debut of U.S. Post Office airmail service. Covered by Rockford's KFLV-AM and attended by thousands, the celebration included a "monster aerial show" acrobatic flight exhibition. The historic "first flight" of Rockford airmail at Rockford (Machesney) Airport was heralded on this oversized commemorative postcard, published by the Rockford Chamber of Commerce "in the interest of aviation." Some cards, like this one, sported a special purple seal announcing the inauguration of North-West Airways' "aeroplane service" on its "Rock River Route." But airmail service at Rockford would prove short-lived, doomed by the Great Depression after 38 months in July 1934.

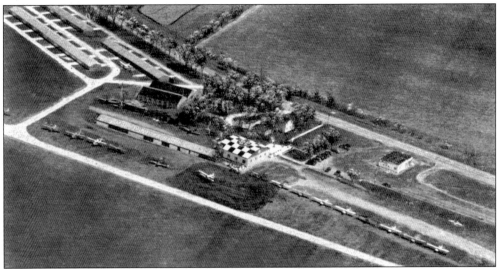

MACHESNEY AIRPORT, 8600 NORTH SECOND STREET. Rockford's first major airport, privately-owned Machesney (Rockford) Airport, designated "RMC" by the FAA, would be eclipsed by the Greater Rockford Airport Authority's 1949 inauguration of Greater Rockford Airport, a civic-owned, 1,200-acre airport built on former Camp Grant land on the city's far southeast side. In 1974, 77-year-old Machesney sold his airport for development of the *c.* 1979 Machesney Park Mall, named in honor of "Rockford's premier air pilot." Mall tax revenues fueled the 1981 incorporation of North Park as today's 20,759-resident Village of Machesney Park. RMC (1928–74) still retains its record as the nation's oldest continuously operated private airport.

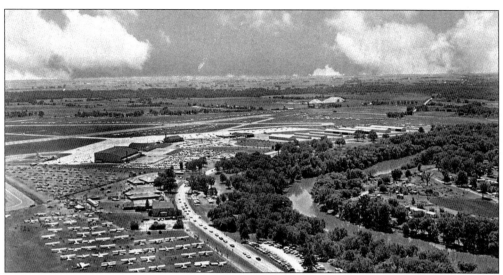

GREATER ROCKFORD AIRPORT, 60 AIRPORT DRIVE. Founded in 1946, the Greater Rockford Airport Authority transformed 1,200 acres of the U.S. Army's decommissioned Camp Grant into a civic general aviation airport. Designated "RFD" by the FAA, Greater Rockford Airport opened in 1949, with passenger service inaugurated in 1950. The GRAA's Aero Industrial Park opened in 1962. Between 1959 and 1969, RFD hosted the Wisconsin-based Experimental Aircraft Association's popular annual summer "Fly-In." Never a strong general aviation passenger airport, given its proximity to Milwaukee and Chicago, 3,000-acre RFD repositioned itself into one of the nation's leading commercial service airports, today ranking as the nation's 23rd largest cargo airport. (Photo: Herzog Photographers)

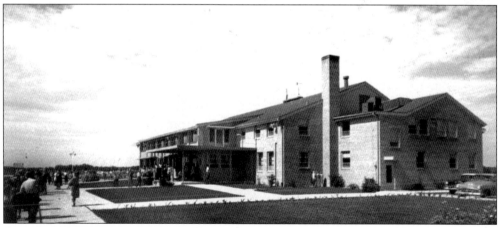

GREATER ROCKFORD AIRPORT TERMINAL, 2 AIRPORT CIRCLE. Following the 1950 establishment of passenger service at Greater Rockford Airport, the Camp Grant Officer's Club was relocated and remodeled into this $400,000 passenger terminal and administration building in 1953. The 1978 federal deregulation of the airline industry, the 1981 air traffic controllers strike, and a deep nationwide recession killed Rockford's already-thin passenger service by the early 1980s. A new state-of-the-art passenger terminal was dedicated in 1988 in conjunction with a short-lived revival of Rockford passenger flight service. Once again without passenger flight service by 2001, limited passenger service was restored in 2003 with Atlanta-based TransMeridian Airlines' charter service to Orlando and Las Vegas.

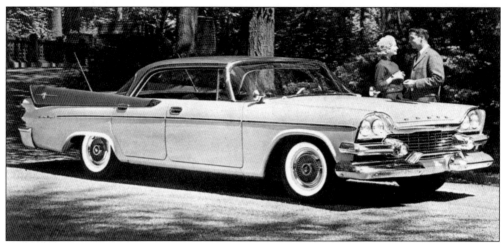

SWEPT-WING '58 CUSTOM ROYAL LANCER BY DODGE, 1957. Colorful and realistic Kodachrome technology drove a postcard revival in 1950s and 1960s. A co-op advertising venture by Chrysler Corp. and Rockford's Craig Motor Co., this postcard showcased Dodge's four-door, 1958 "Swept-Wing" Custom Royal Lancer, heralded as a "new adventure in motoring." Dodge's prestigious top-of-the-line offering, the $3,140 Custom Royal Lancer offered several changes from 1957, including Dodge's first quad headlight system, completely renewed grille and parking light arrangements, and a wider range of engine choices. Options for 1958 included angled rear-mounted antennas and a new electronic fuel injection system mounted on the hemi-head, 361-cubic-inch engine.

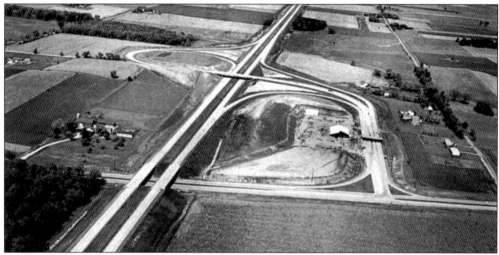

I-90 NORTHWEST TOLLWAY/EAST STATE STREET INTERCHANGE, 1963. Built in 1956–58, the Illinois Tollway's 103-mile I-90 Northwest Tollway indelibly changed Rockford. Planned to run cross-town through downtown Rockford, local objections saw I-90 routed eight miles east, near the Boone County line. A lesser-traveled connecting expressway, U.S. 20 Bypass, was built south of Harrison Road in 1960–62. The interstate spawned Rockford's lopsided urban sprawl growth to the east, draining vitality from downtown and the city's west side. Commercial development around Rockford's I-90/East State Street interchange would begin in the late 1960s. The bustling interchange is today surrounded by restaurants, gas stations, movie theaters, retail stores, and hotels offering nearly 2,800 rooms. (Photo: Herzog Photographers)

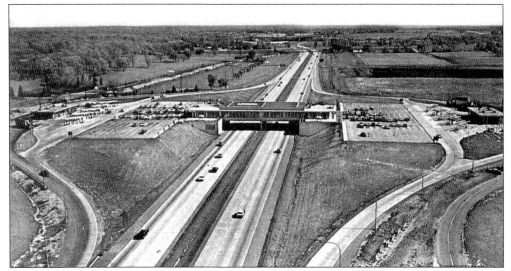

AERIAL VIEW AND OASIS ON ILLINOIS TOLLWAY. Rockford—and the nation—would be radically transformed by the Federal-Aid Highway Acts of 1954 and 1956, which laid the $25 billion groundwork for today's transcontinental Eisenhower Interstate System, a 65,000-plus mile network of high-speed, limited-access highways modeled after the German autobahn. Among the earliest developments would be a 103-mile northern Illinois stretch of the I-90 Northwest Tollway, built in 1956–58 between Chicago and South Beloit, skirting east of Rockford. Spanning 3,113 miles between Boston and Seattle, I-90 ranks as the nation's longest interstate highway. The Illinois tollway's seven travel plazas include a newly-redeveloped regional Oasis in nearby Belvidere. (Courtesy: Mary Lou Liebich Yankaitis)

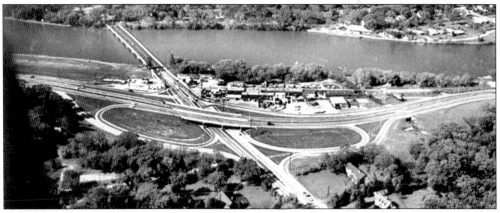

AUBURN-SPRING CREEK-NORTH SECOND "CLOVERLEAF," 1956. Rockford was no exception to the expressway movement that swept through U.S. cities during the 1950s through the 1970s. Between 1956–71, the Illinois Department of Transportation undertook a $6 million, three-phase redevelopment of North Second Street/Dr. Martin Luther King Memorial Drive into a six-lane freeway corridor, running north from East State Street in downtown Rockford to the Rockford/Loves Park border—the first link in a larger local expressway plan that never materialized. As in other communities, expressway construction upheaved older urban neighborhoods, displacing residents in Rockford's now landmarked Brown's Hill and Knightsville neighborhoods. This $1,133,000, c. 1956 interchange was reconfigured and improved to a full cloverleaf in 1969–71. (Photo: Herzog Photographers)

DAVIS'S HAND-PICKED AUTOMOBILES, 1401 BROADWAY, 1957. While the dealership names and car styles have changed, one thing hasn't changed—Rockford's Broadway retailing district remains a leading center of the local used car industry. Davis's, once one of Broadway's leading used car dealers, boasted that all of its automobiles were "hand-picked" by brothers Delmer "Del" and George Davis. Noted this 1957 postcard, "For a fair price and a good automobile, look for the billboard sign and the cars under cover for your shopping pleasure." The enduring dealership is now home to Carl's Cars, Inc., today one of eighteen used car dealerships lining Broadway. (Courtesy: Mathew J. Spinello)

COURTESY AUTO SALES, 1522 SEVENTH STREET, 1957. As "Northern Illinois's largest dealer," D.M. "Swede" Clark's Courtesy Auto Sales used this postcard to pitch "a whale of a deal." Beginning in 1945 with the downtown Clark Brothers dealership run by H.S. "Jack" and D.M. Clark, "Swede Clark's Courtesy" would operate from several Rockford and Loves Park locations between 1953 and 1985, including this Rockford Hudson/Nash/AMC dealership at 1522 Seventh Street (1953–59). Branching into wholesaling in 1974, Clark founded Greater Rockford Auto Auction, one of the nation's oldest and largest independent dealer-only auto auction houses. Clark has sold over one million vehicles in his enduring career. (Photo: Henry Brueckner; Courtesy: Mark D. Fry)

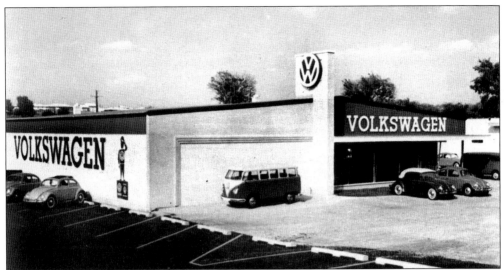

CHUCK THIEL VOLKSWAGEN, 3700 EAST STATE STREET, 1958. An imported German-made Volkswagen "Beetle" or classic split-windshield VW "Microbus" was as near as Chuck Thiel Auto Sales (1958–60), one of the city's early import dealers. As Rockford expanded east along East State toward newly-opened I-90 in the late 1950s and 1960s, numerous greenfield retail developments sprang up between Fairview Avenue and Alpine Road, including Thiel, Fairview Shopping Center, Del Marty Plaza, Don Carter Lanes, Howard Johnson's Restaurant, and the Albert Pick Motel. Thiel, later Park Motor Imports, relocated in 1969 to bigger quarters at 5695 East State, today home to Lou Bachrodt Pontiac-Buick-GMC.

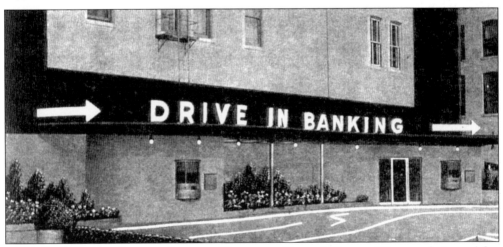

DRIVE IN BANKING CENTER, ILLINOIS NATIONAL BANK & TRUST. The popularity and fast spread of the automobile spawned a host of stay-in-your-car innovations, including "drive-through" car washes, fast food pick-up windows, and an array of restaurant, theater and banking "drive-ins." Among Rockford's "Drive In Banking" pioneers was Rockford-based Illinois National Bank & Trust Co., which built this enduring and since-expanded downtown facility off Chestnut Street at its William Brown Building location, today operating under the Rockford-based AmCore Bank banner. Since the 1950s, drive-in banking centers have become a ubiquitous and convenient mainstay of the nation's modern banking industry. (Courtesy: Mathew J. Spinello)

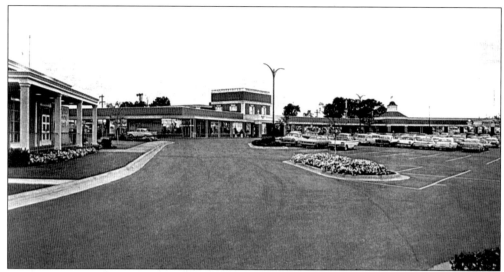

HIGHCREST CENTRE, 1670 NORTH ALPINE ROAD, 1964. Downtown Rockford and the city's urban retail districts declined with the 1950s arrival of the nation's shopping center craze, trailblazed here by several early developments, including the *c.* 1955 Highcrest Centre. Billed as "Rockford's most beautiful shopping center," Highcrest featured acres of free parking and 18 retailers, including Rockford-based department store D.J. Stewart & Co. (center), Highcrest's major anchor from 1962 to 1985. Highcrest was developed by Smith Building Co., the real estate development division of Rockford-based Smith Oil Co., then one of the Midwest's largest wholesale and retail petroleum distributors. (Courtesy: Mark D. Fry)

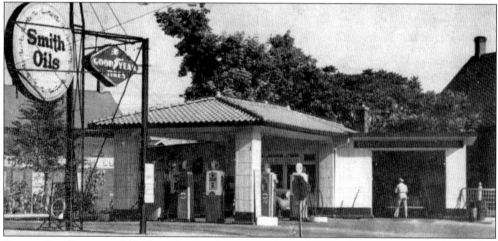

SMITH OIL SERVICE, 910 EAST STATE STREET, 1947. Founded in 1911, Rockford's family-owned Smith Oil & Refining Co. ranked as one of the nation's oldest and largest independent petroleum distributors at its early 1970s height, supplying 375 stations in northern Illinois, southern Wisconsin, and eastern Iowa. Dropping its refining operations, Smith became a wholesale and retail distributor for Gulf from 1947 to 1970, Sunoco from 1970 to 1994, and Phillips 66 since 1994. Sold to Sunoco in 1970, Smith's retail division was purchased by Rockford's Coil Bros. Oil Co. in 1983. Owned by independent operators Ken Peterson and Joe Bergquist, this *c.* 1923 Smith Oil Service last operated as Chuck's East State Sunoco before closing in 1971. (Courtesy: Midway Village & Museum Center)

Six
EDUCATION

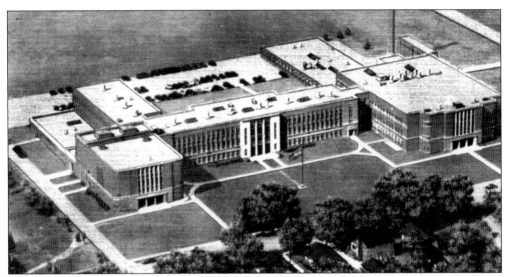

WEST SIDE SENIOR HIGH SCHOOL, 1940 NORTH ROCKTON AVENUE. In 1939–40, Rockford Public Schools built two 2,000-student sister high schools—West and East—to replace downtown's aging and long-overcrowded Rockford High School, which became the new administrative headquarters for the district, today Illinois's third largest. Designed by prominent Rockford architect Jesse Barloga, $1.25 million Rockford West graduated 20,220 students in its 49-year history as a high school. Beloved coach Alex Saudargas led West to back-to-back IHSA boys basketball championships in 1955 and 1956. Notable West High alums include author/writer John Culhane, Hollywood actor Aidan Quinn, 1984 U.S. Olympic diving bronze medalist Ron Merriott, longtime WROK-AM newsman Fred Speer, former *Register Star* editor Chad Brooks, amateur baseball enthusiast Louis F. Marinelli, and pioneering Trans-Atlantic and Trans-Pacific balloonist Ben Abruzzo. A significant force in city leadership, Rockford in the 1970s and early 1980s was largely run by West High alums—Democrat Robert McGaw as mayor (1973–81), Arthur Johnson as superintendent of schools (1974–84), and Delbert Peterson as police chief (1965–85). Closed in May 1989, the now landmarked West reopened as West Middle School the following fall. The district's controversial 1989 closure of 10 schools—of which six were west-side schools, including racially integrated West High—sparked what would grow into a class-action racial discrimination lawsuit against the school district and a costly federal court order to desegregate the district to remedy three decades of bias, segregation, and discrimination against Black and Hispanic students.

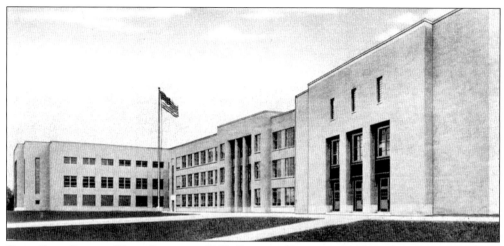

EAST SIDE SENIOR HIGH SCHOOL, 2929 CHARLES STREET, 1944. Built in 1939–40, $1.25 million Rockford East opened concurrently with sister facility West High as successors to downtown's Rockford "Central" High School. Like West, the state-of-the-art, 2,000-student East included a gym, auditorium, swimming pool, rifle range, cafeteria, and "Little Theater." Serving the city's ethnic Swedish east side, East offered a Swedish language course into the 1960s. East, a Rockford historic landmark, today operates as one of Rockford's four public high schools, alongside Auburn, Guilford, and Jefferson. Coach Bob Pellant's 13-0 East E-Rabs won Illinois's Class 4A state high school football championship in 1974. Coach Perry Giardini's 11-3 E-Rabs won the IHSA Class 5A state football championship in 1985.

BISHOP MULDOON HIGH SCHOOL, 120 TAY STREET, 1942. Tudor Gothic-styled Muldoon (1930–70), a Dominican-run Catholic girls parochial high school, was built under the direction of Bishop Edward F. Hoban and named in honor of Peter J. Muldoon (1863–1927), first bishop of the *c.* 1908 Catholic Diocese of Rockford. Nationally known for his social justice work, Muldoon had long championed Catholic parochial education in Rockford. Both Muldoon and the nearby all-boys St. Thomas High School (1910–62) lost their enrollment fights with the diocese's *c.* 1960 co-ed upstart, Boylan Central Catholic High School. Subsequently owned by the Rockford Public Schools as Muldoon Center, this structure was sold in 1989 to non-profit community health care center Crusader Clinic.

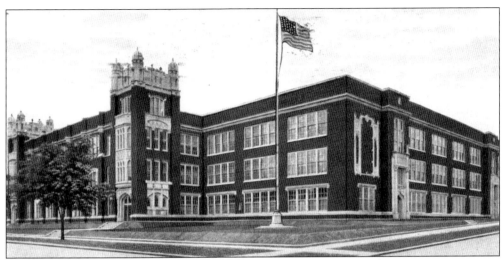

THEODORE ROOSEVELT JUNIOR HIGH SCHOOL, 978 HASKELL STREET, 1935. Under longtime school superintendent Peleg Remington "P.R." Walker, Rockford laid claim to one of the nation's most progressive school systems. With its 1922 establishment of Roosevelt, Rockford was among the earliest U.S. and Illinois districts to join the national junior high school movement, pioneered in Ft. Lauderdale, Florida in 1920. Closed in 1982 during the nationwide post-Baby Boom school enrollment decline of the 1970s and early 1980s, shuttered Roosevelt experience adaptive reuse as an office complex. Following a $4.4 million 1993 renovation, Roosevelt reopened as Roosevelt Community Education Center, home to various adult education programs, district offices, and the 300-student Roosevelt Alternative High School.

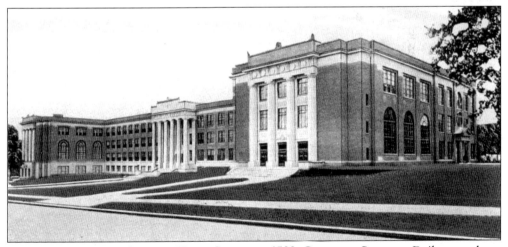

ABRAHAM LINCOLN JUNIOR HIGH SCHOOL, 1500 CHARLES STREET. Built at a then-princely sum of $1,148,000, Abraham Lincoln Junior High opened its doors in 1924 as "the city's most impressive appearing public school." The school offered several then-rare amenities, including a swimming pool and four manual trade training shops. By the early 1940s, Lincoln enrollment averaged some 2,000 students. Operating today as 850-student Lincoln Middle School, the landmarked facility is named for Illinois's most famous citizen, Kentucky-native and "Great Emancipator" president Abraham Lincoln (1809–65), a log cabin-born Springfield lawyer and Illinois legislator who led the nation through the 1861–65 Civil War during his assassination-shortened 1860–65 Republican presidency.

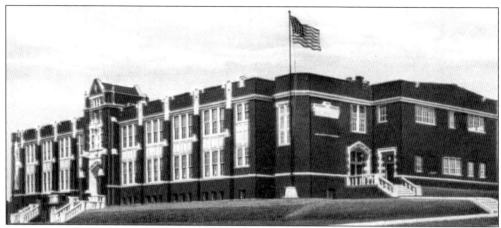

J. HERMAN HALLSTROM SCHOOL, 1300 SEVENTEENTH STREET, 1941. Completed in 1924, the $216,755 Hallstrom School was named for Swedish immigrant J. Herman Hallstrom, Rockford's popular Socialist-leaning firebrand five-term mayor (1921–26 and 1929–32). The City of Rockford's first full-time mayor at age 32, the Labor Party's Hallstrom was one of Rockford's most colorful politicians. A 20th century renaissance man with a varied background as a bricklayer, playwright, newspaper editor, insurance agent, trade union supporter, and architecture buff, Hallstrom left an impressive mayoral legacy of major civic infrastructure, services, zoning, transportation, and educational improvements. Hallstrom School closed in 1989 during a major Rockford Public Schools reorganization.

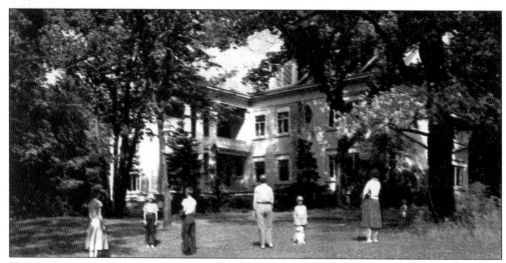

KEITH COUNTRY DAY SCHOOL, 1 JACOBY PLACE. Keith School was founded in 1916 by Belle Emerson Keith, the daughter of prominent Rockford agricultural implement manufacturer Ralph Emerson. Fulfilling her dream of creating a progressive college preparatory school, Keith built her co-ed school upon a Montessori-styled educational setting—combining unique learning opportunities and self-directed study. Started in Keith's downtown home, 420 North Main Street, Keith School in 1920 relocated to the Fred G. Shoudy Mansion (1892–1970) on its current wooded 15-acre campus overlooking riverfront Sinnissippi Park. The oft-expanded 325-student Keith School today operates as an independent non-sectarian college preparatory school for students from age three through the 12th grade. (Photo: Jack Taylor)

Seven
COLLEGE TOWN

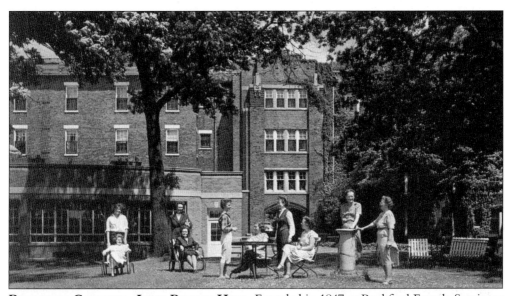

ROCKFORD COLLEGE—JOHN BARNES HALL. Founded in 1847 as Rockford Female Seminary and renamed Rockford College in 1892, the private liberal arts college today ranks as one of Rockford's oldest institutions. Pictured is the $100,000 John Barnes Hall, a 108-student dorm built in 1911. In 1964, Rockford College abandoned its scenic, but landlocked downtown Rockford campus, expanded from eight to nineteen acres between 1852 and 1964, for today's 130-acre, 26-building campus at 5050 East State Street. Alma mater of famed social reformer Jane Addams (1860–1935), a Class of 1881 valedictorian and 1931 Nobel Peace Prize recipient, Rockford College once ranked as the nation's second-oldest women's college. A leading educator, Rockford College pioneered evening adult education courses in Illinois in 1919. Men, first admitted to Rockford College during World War II as part of cooperative educational programs offered in conjunction with the Illinois Institute of Technology, were admitted beginning in 1955 with the creation of a men's college, gaining full admission to a co-educational Rockford College in 1959. In more recent decades, distinguished Rockford College graduates from the new campus have included Gretchen Kreuter, Rockford College's first alumna president (1987–1992), and syndicated Milwaukee *Journal Sentinel* columnist and author Jacqueline Mitchard. Financial problems in the 1980s and early 1990s forced land sales to cut the college's mounting debts, paring the campus from 304 to 130 acres. Today, Rockford College offers 30 majors, encompassing four Bachelors and two Masters degree programs. (Photo: Jack Taylor)

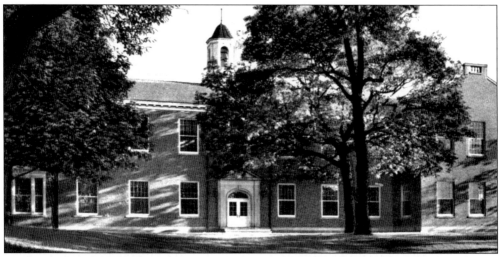

JOHN HALL SHERRATT LIBRARY, ROCKFORD COLLEGE. Built as one of the last major developments on Rockford College's old downtown campus, the John Hall Sherratt Library opened in the fall of 1939, dedicated by Glencoe, Illinois-native Archibald MacLeish, Librarian of Congress (1939–44) and a three-time Pulitzer Prize winning poet. A trailblazing facility, Rockford College's Sherratt Library was the nation's first small college library to utilize divisional reading rooms corresponding to the four general curriculum divisions. With the exception of the *c.* 1950 Jewett Science Building at 401 Division St., today home to the Winnebago County Department of Health, the remainder of the old campus was razed and redeveloped in 1968 for the Rockford Housing Authority's Campus Towers high-rise apartment development.

ROCKFORD COLLEGE HOUSES ALONG BLUFF STREET. In its "old campus" heydays downtown, Rockford College's well-heeled surrounding neighborhoods on College Avenue and Bluff, and Division and Seminary Streets once encompassed a prestigious residential enclave that included students, professors, and leading city residents, including knitting scion and college benefactor O.G. Nelson. As Rockford College's small eight-acre campus built up between 1852 and 1920 with various developments including Adams, Sill, Lathrop, John Barnes, Talcott, Middle, and Linden Halls around its U-shaped quadrangle commons, facilities were added adjacent to the campus along Bluff Street. Those facilities included the Emerson Hall music department building and (William Arthur) Maddox House, named for the former Rockford College president. (Courtesy: Mark D. Fry)

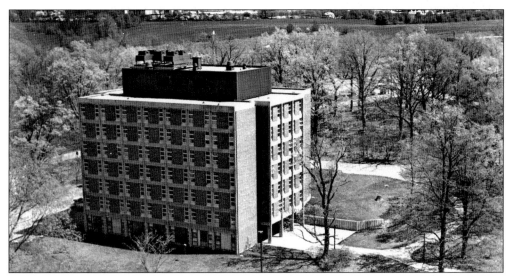

MARY McGAW HALL, ROCKFORD COLLEGE, 5050 EAST STATE STREET. Built in 1969 and long known simply as the "new dorm," the seven-story McGaw Hall dormitory was constructed in a wooded area of Rockford College's then 304-acre campus to "provide the privacy and quiet study atmosphere desired by students." Housing 210 students in single and double rooms, each floor of the dorm offered amenities including a laundry area, living room, typing areas, and small kitchen-lounges. "New Dorm" was renamed Mary McGaw Hall following a 1977 gift from McGaw's father, Foster McGaw, then president of the American Hospital Supply Co., which is part of today's Baxter International.

ALBERT M. JOHNSON LIVING CENTER, ROCKFORD COLLEGE, 5050 EAST STATE STREET. One of the pioneering buildings on Rockford College's new East State Street campus, the *c.* 1961 Albert M. Johnson Living Center was built as the social center for the college's early male residence cluster, which included adjacent dormitories (Bruce) Olson Hall, (Louis) Caster Hall, and (O.G.) Nelson Hall. In its early days, the Johnson Living Center included a reception area, double fireplace, large living room, and television room, serving as a meeting place for "informal dates, dances, open houses and other social events." The Johnson Center today houses Rockford College's popular "Lion's Den Sports Pub & Coffee House," the campus's contemporary meeting spot for a snack and entertainment.

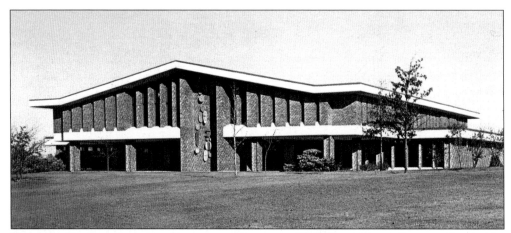

HOWARD COLMAN LIBRARY, ROCKFORD COLLEGE, 5050 EAST STATE STREET. Funded by the Howard Colman Foundation, this $1.5 million library on Rockford College's newly developed East State Street campus was named in honor of Rockford industrialist, philanthropist, and inventor Howard Colman, founder of Rockford's Barber-Colman Co. and a longtime Rockford College benefactor. The *c.* 1967 Colman Library, the intellectual and visual center of the Rockford College campus, was built with a 210,000-volume capacity and could seat 540 students—270 at individual study carrels. In 1971, the decorative fired clay "Adiar Tiles" by art professor Arthur Adair (1961–74) were installed on the Colman Library façade. Among the symbols and hieroglyphics represented are those of Mayan, Moorish, Chinese, Greek, and Celtic roots. (Photo: Thomas Guschl)

BLANCHE WALKER BURPEE CENTER, ROCKFORD COLLEGE, 5050 EAST STATE STREET. Alumni gifts provided over 60 percent of the funding for the 1962–64 construction of Rockford College's $905,000 Burpee Center student union, the "hub of activities at Rockford College." An addition was constructed in 1970, adding Regents Hall and the Grace Yates Roper Lounge, named in honor of the 26-year college trustee and 1956 honorary alumna. A central figure in contemporary Rockford College history, visionary Class of 1895 alum Burpee obtained options in 1928 on an undeveloped 400-acre rural East State Street tract, which would come to comprise Rockford College's present campus. It was developed beginning in 1960 and opened in 1964, when the old downtown campus was vacated. (Photo: Thomas Guschl)

MAIN DINING ROOM—BLANCHE WALKER BURPEE CENTER, ROCKFORD COLLEGE, 5050 EAST STATE STREET. The main dining room in Rockford College's Blanche Walker Burpee Center enjoyed great popularity, as evidenced by the packed house pictured here. As Rockford College's student union, the Burpee Center served as the non-academic center of campus life, housing recreational facilities, the campus bookstore, an area for commuter students, a snack bar, a coffeehouse, two large cafeteria dining rooms, "attractive" lounges, the campus radio station, administrative offices, and student publication offices. A multi-purpose space, Burpee Center's main dining room also saw occasional double duty in off-hours as the site of many college dances.

HENRY SCARBOROUGH HALL, ROCKFORD COLLEGE, 5050 EAST STATE STREET. Rockford College's main academic classroom building, *c.* 1961 Scarborough Hall was built through a memorial gift by Chicago resident Mrs. Henry Scarborough. In addition to classrooms, the building also houses the Severson Auditorium. A progressive building for its day, Scarborough Hall featured a "new" two-level seminar classroom design, encompassing a lower level seminar table seating 15 students, and the professor, with an upper level featuring built-in desks surrounding the seminar area for an additional 20 students.

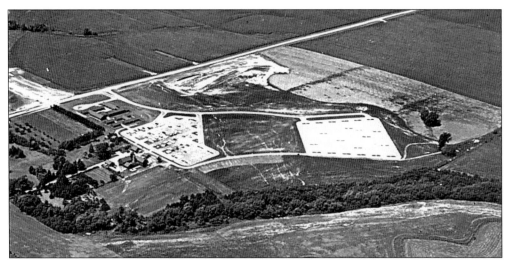

ROCK VALLEY COLLEGE, 3301 NORTH MULFORD ROAD. In the early 1960s, former Rockford High and West High principal James Blue championed the creation of a public two-year community college in Rockford. Blue's dream became a reality with the 1964 founding of Rock Valley College (RVC) and the 1966 development of a permanent 217-acre northeast side main campus near Mulford and Spring Creek Roads (top). Opened to students in 1965, RVC's three-phase, $16 million founding core campus was built in the mid-to-late 1960s and early 1970s. Several early RVC anchor facilities, including the Student Center (bottom), were designed by internationally known California architect Ernest Kump. Today, a much-expanded RVC educates over 12,000 full and part-time undergraduate students annually, servicing District 511 residents in Winnebago and Boone counties and portions of Stephenson, Ogle, McHenry, and DeKalb counties. In addition to its main campus, RVC also operates four off-campus metro Rockford sites and offers courses at over 50 adult and community education sites throughout the area. (Top Photo: Carlson Commercial Photography)

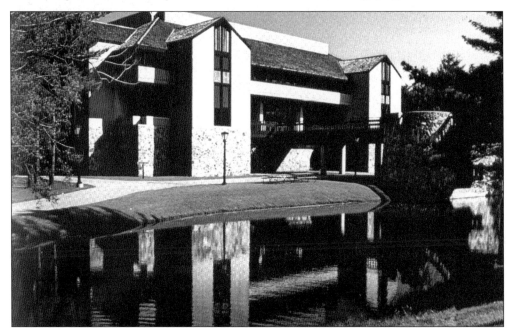

Eight

A LEGACY OF CARING

TRINITY LUTHERAN CHURCH CONFIRMATION CLASS, 1922. This Real-Photo postcard served as a friendly reminder to Island Avenue teen Mae Mortinson to attend Trinity Lutheran Church's upcoming Sunday confirmation class. Notes the hand-written caption from founding longtime pastor Rev. Hugh M. Bannen (1896–1943): "'The Joys of Youth' sermon subject to our class Sunday morning. Come on time to go in together." Between 1900 and 1942, the number of churches in Winnebago County nearly doubled to 113, and by 1967 had grown to 207. As "The Church City," a 1959 survey indicated that 90 percent of Rockford households professed church membership, far above Illinois's 63 percent average and the 61 percent national mark. Today, Rockford alone is home to more than 200 congregations.

TRINITY LUTHERAN CHURCH, 200 NORTH FIRST STREET. One of Rockford's largest congregations, fast-growing Trinity Lutheran Church had long outgrown its *c.* 1900 church at 218 North First Street by the Baby Boom post-war years, when 3,700-member Trinity ranked as one of the nation's largest Lutheran congregations. Committed to downtown Rockford, Trinity built this $690,000, 1,040-seat Georgian Colonial church, designed by Rockford architect Gilbert A. Johnson, in 1955–56. An adjacent $350,000 education wing was added in 1959–60. The church was served by only four pastors in its first 100 years—O. Garfield Beckstrand (1919–70) and his son, O. Garfield Beckstrand II (1947–82) served 87 years, 35 years as senior pastors from 1947 to 1961 and 1961 to 1982, respectively. (Photo: Henry Brueckner)

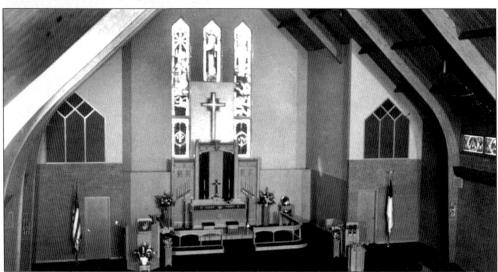

TABOR EVANGELICAL LUTHERAN CHURCH, 2233 TWELFTH AVENUE. Numbering five congregations by 1900, no Protestant denomination saw greater growth in Rockford between 1900 and World War II than the Lutherans, who would establish an additional nine congregations between 1907 and 1942. An offshoot of Zion Lutheran, Tabor Lutheran Church was founded in 1925. Replacing its original $100,000 Norman Gothic church, Tabor erected this 550-seat $275,000 sanctuary in 1956–57, adding a $700,000 education wing in 1990. Known for the stability of its pulpit, Tabor from 1928 to 1969 was headed by Rev. Clarence H. Anderzon, widely regarded as Rockford's senior-ranking church pastor.

ST. MARY'S CATHOLIC CHURCH, 517 ELM STREET, 1960. Celebrating the Diamond Jubilee anniversary of the parish's 1885 founding, the Augustinian Fathers heading St. Mary's Catholic Church spearheaded a complete renovation of the downtown church. Designed by Chicago architect James F. Egan in a Diminished Gothic style and built between 1885 and 1887 as Rockford's second Roman Catholic church, the parish is famed for its Lourdes-inspired *c.* 1928 subterranean grotto. In 1962, a $200,000 arson fire gutted the sanctuary, which was subsequently rebuilt. An adjacent parochial school was operated by Augustinian Nuns between 1888 and 1974. Home to Spanish language masses between 1970 and 1992, the parish since 1996 has been home to Rockford's Latin Mass community as St. Mary's Oratory, administered by the Institute of Christ the King. (Photo: Brueckner & Clark)

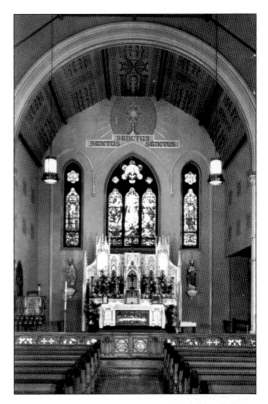

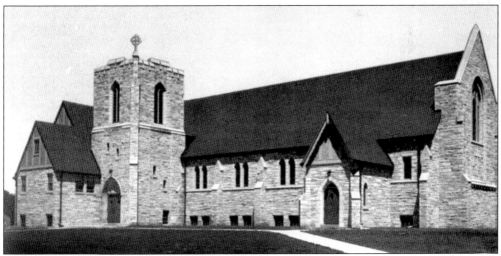

WESTMINSTER PRESBYTERIAN CHURCH, 3000 RURAL STREET, 1951. With its original 1858 church at South Second and Oak Streets destroyed in a 1946 blaze, members of Westminster Presbyterian Church set themselves to the task of rebuilding. Loss of the 88-year-old structure, one of Rockford's oldest churches, was only partially covered by insurance. The congregation dedicated this Normandy-styled church facility on the city's newly developing east side in 1951. An early Rockford congregation, Westminster was founded in 1856 when 22 Presbyterian members of Rockford's First Congregational Church amicably split to form their own Presbyterian congregation. (Photo: C. Carroll Thill)

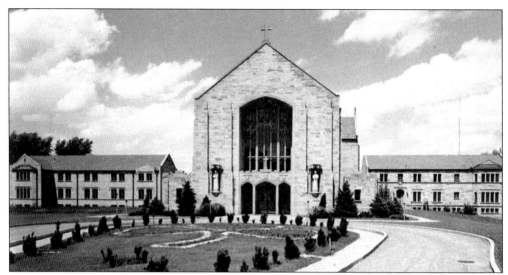

ST. PATRICK'S CATHOLIC CHURCH, 2505 SCHOOL STREET, 1952. A large influx of immigrant European Roman Catholics and the city's phenomenal growth fueled the formation of six Rockford parishes between 1900 and 1930. In 1919, the Catholic Diocese of Rockford organized St. Patrick's, 2009 West State, to serve Rockford's far west side and the city's Irish Catholic population. Following post-World War II residential development, the parish built this $600,000 Modified Gothic church and rectory facility on this 15-acre greenfield site in 1952. The 700-seat Indiana limestone church, decorated with Italian marble sanctuary furnishings, was designed by Chicago architects K.M. Vitzthum and J.J. Burns. Founded in 1929, St. Patrick's School operated at this site from 1953 to 1995. A *c.* 1955 convent for school nuns now houses the parish's community center.

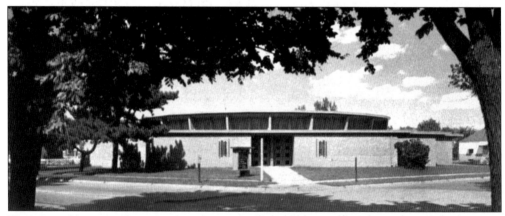

KILBURN AVENUE CHURCH OF CHRIST, 1705 KILBURN AVENUE. Among the new Protestant denominations to appear in Rockford between 1900 and 1940 was the Church of Christ, pioneered in 1927 by Rockford Church of Christ. Long housed in rented South Main and West Jefferson locations, the congregation in 1952 built this enduring $75,000 350-seat Frank Lloyd Wright-styled "church-in-the-round," designed by architect Hendrick P. Maas. The congregation, renamed West Jefferson Street Church of Christ with its 1936 relocation to 2425 West Jefferson, took on its longtime Kilburn Avenue designation in 1952. Disbanded in the 1980s, the church is today home to Christian Union Full Gospel Church Ministries. (Photo: Henry Brueckner)

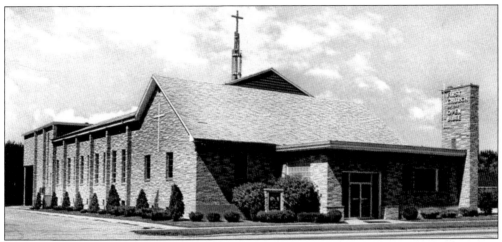

FIRST CHURCH OF THE OPEN BIBLE, 8202 NORTH SECOND STREET. Among metro Rockford's early "evangelical" congregations was Machesney Park's First Church of the Open Bible, founded in 1954. "Aggressive and friendly" Open Bible erected this 300-seat, $45,000 church in 1958, building additions in 1961 and 1964–65. Embracing television in 1962, Open Bible and longtime founding pastor Donald M. Lyon became well known for their nationally-aired weekly *Quest for Life* on WTVO-17. Lyon left Open Bible in 1977 to found Faith Center, at 4701 South Main. In 1991, Open Bible relocated to a new $600,000 facility at 5501 Windsor Road, as Windsor Heights Community Church. (Photo: Carlson Commercial Photography)

FIRST ASSEMBLY OF GOD, 5950 SPRING CREEK ROAD, 1984. Mirroring the national trend toward evangelical "mega churches," First Assembly of God built itself into one of Rockford's largest and most prominent churches. Founded in 1929 by a small group of Swedish Pentecostals led by Olga V. Olsson, First Assembly moved from 804 Second Avenue to its current 40-acre site in 1971. Pictured is the congregation's Easter 1982 musical drama *Resurrection* and its famed "Living Cross." In 1988, fast-growing First Assembly dedicated its new $7 million "Table for 5000" sanctuary. First Assembly ministries today include Christian radio stations WGSL-FM and WQFL-FM, Kiddie Kollege daycare, a bible college, and "Christian Life" schools and retirement centers. (Courtesy: Mary Lou Liebich Yankaitis)

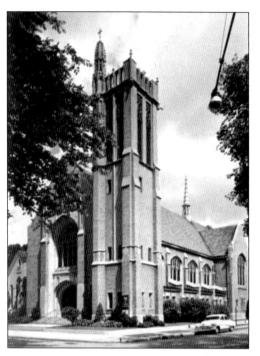

EMMANUEL LUTHERAN CHURCH, 926 THIRD AVENUE. A steady influx of Swedish immigrants saw the Lutheran Church grow spectacularly in Rockford. Emmanuel was founded as the city's second Swedish Lutheran congregation in 1882. In Rockford's pre-Depression 1920s economic boom, fast-growing Emmanuel replaced its *c.* 1883 church with this $170,000 Gothic-styled church, a 1,100-seat structure feted as Winnebago County's most expensive church. Billed as "The Church Beautiful," Emmanuel furnishings include a wood altar carving of Leonardo DaVinci's *Last Supper* by Austrian artisan Alois Lang. Emmanuel's altar window, said by admirers to be "a masterpiece in purple and ruby art glass," is a replica of Thorwaldsen's *Christ*. A $450,000 educational and chapel addition was added in 1958. (Photo: Henry Brueckner)

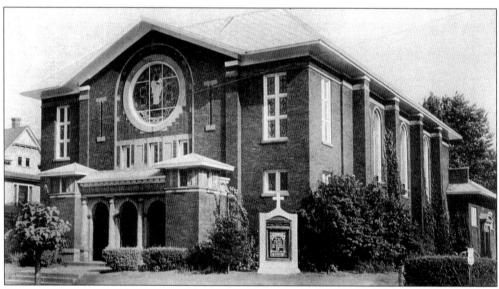

GRACE METHODIST-EPISCOPAL CHURCH, 1401 WEST STATE STREET. Organized by the West End Evangelical Society in 1891 as an outreach Sunday School program, fledgling Grace met in various West State Street and Avon Street locations until the 1916 dedication of this $35,000, 1,000-seat Romanesque church. Membership peaked at 1,400 in the 1950s, years when the sanctuary was renovated and a $121,000 educational wing was added. Membership later declined as parishioners followed growth to Rockford's east side. Grace relocated to suburban Loves Park in 1991, building its current $900,000 church on a seven-acre site at 3555 McFarland Road in 1994–95. The old Grace facility is today home to House of Refuge Church. (Courtesy: Mark D. Fry)

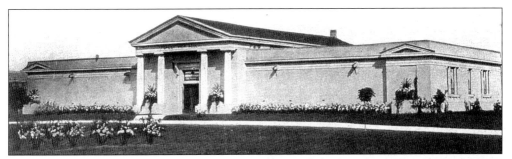

FOREST VIEW ABBEY, 2123 NORTH MAIN STREET. Built by Batavia resident Willis Addison Merrifield Sr. (1855–1929), 600-crypt Forest View Abbey mausoleum (1913–85) was designed by leading Rockford architect Jesse Barloga as the ultimate final resting place for Rockford's rich and famous. Luxuriously appointed with marble, carpeting, and stained glass, the $81,320 Forest View interred some 300 notables, including Barloga, 1896 Olympian-turned-physician Francis Lane, industrialists William Fletcher Barnes and William Worth Burson, retailer David Turkenkoph, German-born concert pianist Herman Belling, and numerous Civil War and World War I veterans. But the Great Depression bankrupted the mausoleum's endowment fund. Long deteriorating and abandoned since the 1960s, Forest View Abbey was demolished through eminent domain in 1985. Some 200 bodies were privately re-interred between the 1960s and 1985, with those remaining re-interred at neighboring Greenwood Cemetery. (Courtesy: Mark D. Fry)

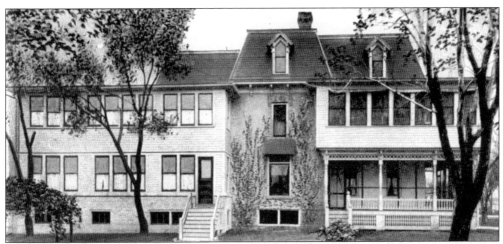

ELIZABETH MCFARLANE W.C.T.U. HOME FOR CHILDREN, 1904–20 NORTH MAIN STREET. Established by the North Rockford Women's Christian Temperance Union (c. 1892) with a $10,000 gift from sisters Mary and Anna Beattie, the 10-room, 100-child Elizabeth McFarlane W.C.T.U. Home for Children (1920–37) operated in the since-razed Charles Brown Home. An outreach of the North Rockford W.C.T.U.'s c. 1908 North Rockford Community House, the orphanage served nearly 2,000 children. Ahead of its time, the non-sectarian Protestant Christian orphanage also operated a day nursery for working mothers. In 1927, the McFarlane Home built a $40,000 children's hospital, which also housed the Community House's convalescent North Rockford Hospital. Much expanded over the years and later renamed North Rockford Convalescent Home, the facility today operates as Rockford-based Wesley Willows' "Willows on Main" skilled nursing care facility. Namesake founder and trustee Elizabeth McFarlane served as the orphanage's superintendent from 1920 until her death in 1934. (Photo: T. Hoover)

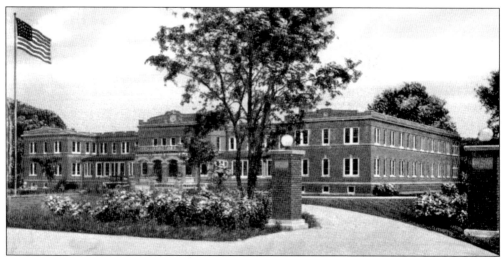

EASTERN STAR & MASONIC HOME, 2400 SOUTH MAIN STREET, 1945. Built by the Order of the Eastern Star (OES), the women's Masonic branch, Rockford's *c.* 1922 Eastern Star & Masonic Home was designed by Rockford architect Charles W. Bradley. Enlarged to serve 100 residents in 1925, the OES Home was located on a scenic 5.5-acre site overlooking the Rock River and Blackhawk Park. Feted by the Rockford *Morning Star* as resembling a "small deluxe apartment-hotel," this facility offered private rooms, a completely-equipped 16 bed infirmary, 3 sun rooms, an auditorium, and several living rooms. Closed in 1976 and sold in 1977, the facility reopened in 1978 as the 110-room River Oaks Retirement Home. Closed in the late 1990s, River Oaks awaits redevelopment.

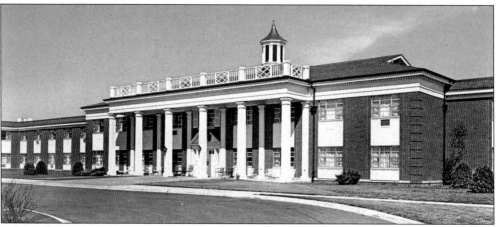

WESLEY WILLOWS RETIREMENT RESIDENCE, 4141 ROCKTON AVENUE. Sponsored by the United Methodist Church as a non-denominational retirement residence, Wesley Willows opened on this 45-acre northwest side campus in 1966 as a 200-resident facility offering single rooms, apartments, and a 30-bed Medicare-certified Health Center. Today offering duplex cottages, independent-living, personal care apartments, skilled nursing care, and an Alzheimer Activity Center through its Wesley Willows and Willows Health Center facilities, Wesley Willows also operates the Willows on Main skilled nursing care facility at the former North Rockford Convalescent Home, at 1920 North Main. Adjacent to Wesley Willows' Rockton Avenue campus is its 110-acre Willow Ridge at Wesley Willows development, offering "distinctive homes for the active adult 60+."

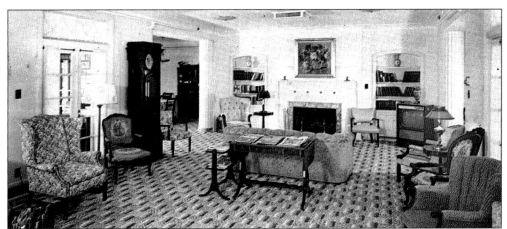

COMMUNITY LIVING ROOM—P.A. PETERSON HOME, 1311 PARKVIEW AVENUE, 1962.
Rockford's oldest retirement facility, the non-profit P.A. Peterson Home was established in 1942 through a $500,000 bequest from Swedish immigrant Pehr August "P.A." Peterson, a leading Rockford industrialist, philanthropist, and venture capitalist. Operated by Lutheran Social Services of Illinois since 1974 and later renamed P.A. Peterson Center for Health, the facility expanded over the years to offer "a complete continuum of care." LSSI also operates the independent living Peterson Meadows Retirement Community, at 6401 Newburg Road. Wrote resident Lillian Angstrand of the P.A. Peterson Home, "Enjoy the home very much and seem to keep busy each day." (Photo: Henry Brueckner)

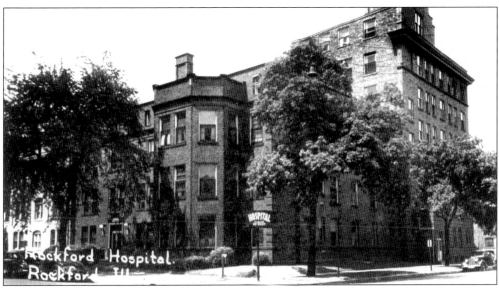

ROCKFORD (MEMORIAL) HOSPITAL, 507 CHESTNUT STREET. Founded in 1885 as the city's first hospital, Rockford Hospital quickly grew in both facilities and stature. A since-disbanded School of Nursing was established in 1889 and hospital additions were constructed in 1888, 1890, 1903, and 1908. A $60,000 six-story South Court Street addition (background right) was built in 1913, adding 50 beds. Renamed Rockford Memorial Hospital in 1942, the landlocked downtown hospital built a 200-bed facility on a 15-acre campus at 2400 Rockton Avenue in 1951–54. Following the relocation, the downtown RMH campus was razed for new downtown development.

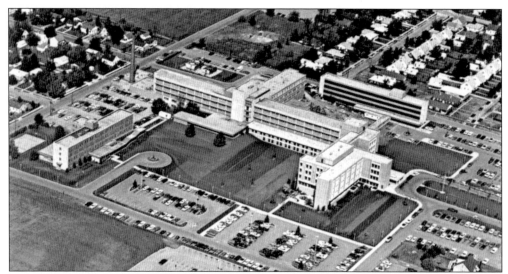

ROCKFORD MEMORIAL HOSPITAL, 2400 ROCKTON AVENUE. Rising admissions, a landlocked hospital, and the tight post-World War II squeeze of downtown development and traffic gridlock spurred Rockford Memorial Hospital's 1951–54 development of its new $5 million, 200-bed Rockford Memorial Hospital on this 15-acre campus. Regarded as "one of the most modern hospitals in the country," the new RMH was financed largely by donations from Rockford's manufacturing community. Today operating under the aegis of Rockford Health System, 28-acre RMH has expanded into a 396-bed tertiary care hospital. "Centers of Excellence" include its Children's Medical Center, Heart & Vascular Center, Neurosurgery, Orthopedics/Physical Therapy, Primary Care, Level 1 Emergency Trauma Services, and Women's Health Services.

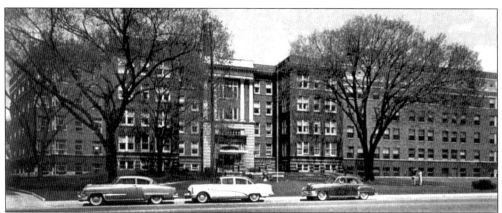

SWEDISHAMERICAN HOSPITAL, 1400 CHARLES STREET. A $175,000 Swedish community fundraising drive made the 55-bed SwedishAmerican Hospital a reality in 1918. A since-disbanded School of Nursing was established in 1919. Built on a three-acre downtown campus in Rockford's Midtown District, SwedishAmerican was designed by prolific Rockford architects Edward Peterson and Gilbert Johnson. A major early supporter, trustee, and board president would be Swedish immigrant and prominent Rockford industrialist, philanthropist, and venture capitalist Pehr August "P.A." Peterson, lovingly remembered as SwedishAmerican's "Grand Old Man." Given community need and its great success, sizeable five-story additions were built in 1940–42 and 1947–53, growing SwedishAmerican into a 200-bed facility.

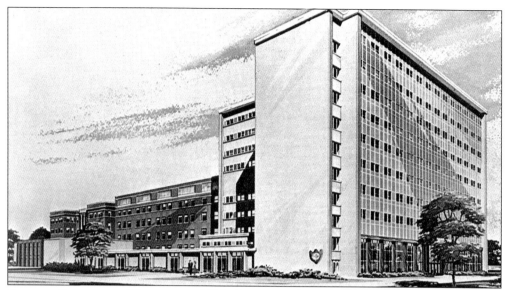

SWEDISHAMERICAN HOSPITAL, 1400 CHARLES STREET. Between 1963 and 1973, SwedishAmerican enlarged to 330 beds with the $5.5 million development of this 10-story addition, the city's first high-rise development since the 1932 completion of the Rockford News Tower. Named a prestigious "Top 100 U.S. Hospital" by Baltimore-based health data firm HCIA in 1999, SwedishAmerican in 2000–02 embarked on a massive $32 million campus renovation and expansion. Operated today as a 400-bed, full-service hospital under the aegis of SwedishAmerican Health System, specialty programs include cardiovascular medicine, cancer treatment, osteoporosis prevention, psychiatry/mental health, general and specialty pediatrics, geriatrics, women's services, orthopedics, occupational health, and gastroenterology.

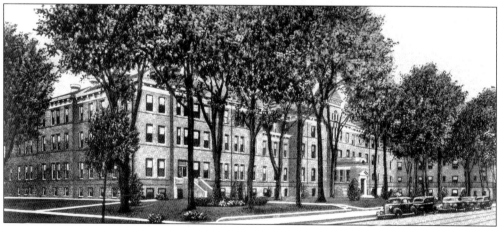

ST. ANTHONY HOSPITAL, 1401-15 EAST STATE STREET. Serving Rockford's east side, the 18-bed St. Anthony Hospital was established in 1899 by Peoria's Third Order of St. Francis. The hospital enlarged as Rockford grew, eventually expanding into a 195-bed facility. Like Rockford Memorial, St. Anthony also relocated from downtown to a new outlying greenfield campus. The old St. Anthony Hospital complex, demolished in 1967, was redeveloped with the $3 million, nine-story Camelot Tower professional office building, purchased by neighboring SwedishAmerican Hospital in 1997. Development of Camelot Tower was spurred by "an urgent need for modern, professional office space in Rockford."

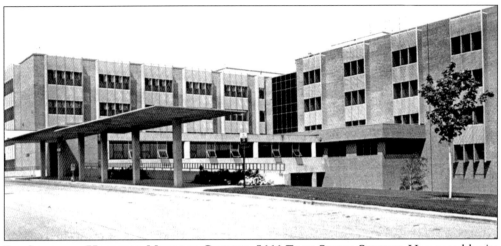

St. Anthony Hospital Medical Center, 5666 East State Street. Hampered by its aging facilities, a landlocked campus, and its stone's-throw proximity to SwedishAmerican Hospital, St. Anthony's closed its downtown hospital in 1963 in favor of this new 200-bed facility, located on a 75-acre campus on Rockford's newly-developing far east side. Since renamed OSF St. Anthony Medical Center and now encompassing a 109-acre campus, the expanded regional 254-bed tertiary care facility is today known for its Level 1 Trauma Center, Regional Heart Institute, Center for Cancer Care, Women's Center, and Illinois Neurosciences Institute. OSF St. Anthony's received National Research Corporation's 2002 and 2003 Consumer's Choice Award.

St. Anthony College of Nursing, 5658 East State Street. Rockford's OSF St. Anthony Medical Center established its St. Anthony School of Nursing in 1915. Operated by Peoria's Sisters of the Third Order of St. Francis, St. Anthony School of Nursing opened this facility in 1969. Long operated as a diploma nursing program, the school reorganized as St. Anthony College of Nursing with its 1990–91 transition into a degree-granting BSN baccalaureate program. Other area nursing programs include those operated by Rock Valley College and the University of Illinois College of Medicine at Rockford.

Nine
CAMP GRANT
1920–1946

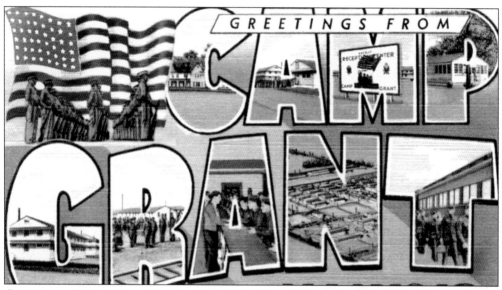

GREETINGS FROM CAMP GRANT, ILLINOIS. After distinguished service training over one million soldiers in World War I, Camp Grant (1917–46) was decommissioned by the U.S. Army in 1923 and subsequently leased to the Illinois National Guard as a Guard training center. Between 1933–36, Camp Grant also occasionally housed Depression-era Civilian Conservation Corps work camps. In November 1940, the Army reactivated and largely rebuilt its 3,280-acre Camp Grant cantonment 5 miles south of downtown Rockford. The $9 million project to build over 500 new buildings employed nearly 6,000 civilians, who transformed Camp Grant into a state-of-the-art recruit reception center and medical training facility,feted as "one of the most beautiful Army posts in he country." As the nation's largest Recruit Reception Center, Camp Grant processed over 330,000 soldiers between 1941 and 1943, when recruit reception duties were transferred to Fort Sheridan in north suburban Chicago. And as the Army's principal medical training facility, nearly 100,000 military medical personnel were trained in Camp Grant's intensive Medical Department Replacement Training and Medical Unit Training programs. From 1943 to 1945, Camp Grant also housed a prisoner-of-war camp for German POW's. Among Camp Grant's 2,500 POW's by war's end were members of Nazi general Erwin Rommel's elite Saharan "Afrika Korps." Following the end of World War II, Camp Grant converted into a demobilization center before its decommissioning and return to civilian use.

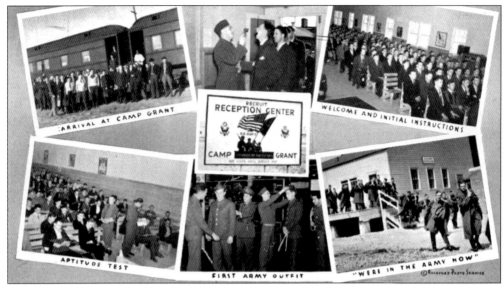

CAMP GRANT—RECRUIT RECEPTION CENTER, 1943. Processing as many as 22,000 rookies monthly, over 330,000 in all during World War II, Camp Grant served as the nation's largest Recruit Reception Center between 1941–43, when Recruit Reception duties were transferred to suburban Chicago's Fort Sheridan. As seen here, incoming recruits and draftees undergoing Recruit Reception were examined for physical and mental defects, given aptitude and orientation tests, outfitted for Army life, and inoculated against typhoid and smallpox before being shipped out to their assignments in Army camps across the nation. Waiting to be "shipped out anytime," Pvt. Ray Lawson found a few moments to send this postcard back home to Ripon, Wisconsin. (Photo: Rockford Photo Service)

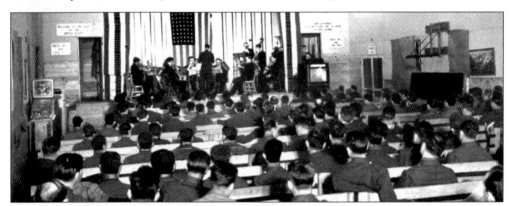

SPECIAL ENTERTAINMENT—RECREATION HALL, 1942. In addition to billiards and ping-pong, soldiers also enjoyed a regular slate of special recreational activities at this facility, one of several Camp Grant recreation halls. During their brief Recruit Reception stay or 13-week Medical Department Replacement Training Center training, Camp Grant soldiers enjoyed a wide variety of special cultural programs, including live theater plays and, as pictured here, a performance by Rockford's concert orchestra. Headliners entertaining troops in Rockford included: Rockford-born Hollywood starlet Barbara Hale; five-time pocket billiards champion Erwin Rudolph; Metropolitan Opera tenor John Carter; stage and screen star Harpo Marx; Chicago *Tribune* publisher Col. Robert R. McCormick; WLS Barn Dance headliners Lulu Belle and Scotty. (Photo: Rockford Photo Service)

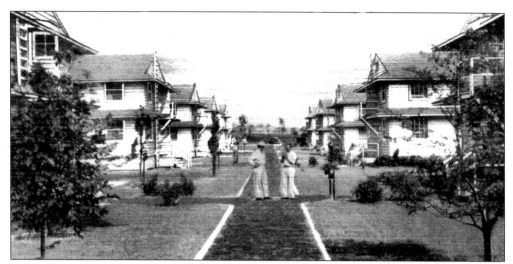

BARRACKS, RECRUIT RECEPTION CENTER. Famed as a World War II Recruit Reception Center, Medical Department Training Center, and POW Camp, virtually unknown is the work of Camp Grant's various "specialist schools." By early 1944, some 16,000 soldiers had been trained for service as cooks, bakers, mess sergeants, buglers, chauffeurs, truck drivers, clerks, mechanics, sanitary technicians, veterinary technicians, and meat and dairy inspectors. Additionally, nearly 1,500 men attended Camp Grant's medical administrative prep school, with another 1,500 attending its officer candidate school. The sender of this card, Pvt. Rex B. Ennis of Augusta, Michigan, shipped out for assignment as a clerical typist.

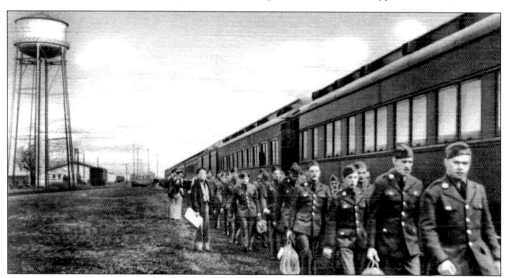

SOLDIERS LEAVING CAMP GRANT, 1941. As the U.S. Army's largest World War II Recruit Reception Center, Camp Grant was capable of processing 22,000 enlistees and draftees into military service monthly. During its 1941–43 tenure as a Recruit Reception Center, 330,000 rookie soldiers were processed through Camp Grant and shipped out for basic training and eventual wartime military assignments through the camp's Chicago, Burlington & Quincy Railroad passenger facility. As had been the case in World War I, the nation's passenger and freight railroads played a critical wartime role by effectively moving troops and materials vital to military success.

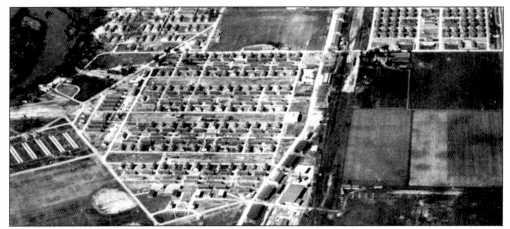

CAMP GRANT—AIR VIEW LOOKING NORTH, 1943. In this aerial view, visible in the foreground and at center are the Medical Replacement Center's barracks and supply depots. Seen at top right is the camp's Recruit Reception Center, where recruits and draftees were outfitted and inducted into Army life. At top left is Camp Grant's extensive hospital ward. The camp's headquarters is seen on the looped drive at the top left. Since its 1946 deactivation and sale, Camp Grant's 3,280 acres were redeveloped for a variety of uses, including Greater Rockford Airport, 334-acre Atwood Park, residential neighborhoods, industrial factories, U.S. Bypass 20, and retail business strips along Sandy Hollow Road and Eleventh Street. (Photo: Rockford Photo Service)

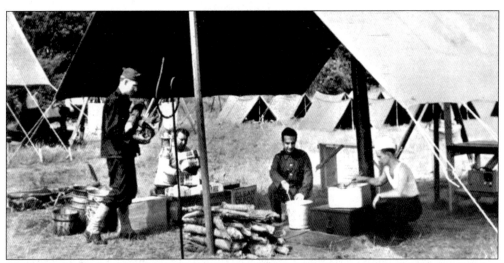

CAMP GRANT—"SLUM" IN THE MAKING, 1942. In addition to serving as a prisoner-of-war camp for German POW's and as the Army's largest Recruit Reception Center, Rockford's Camp Grant played another critical wartime role as one of two U.S. medical training centers. As the Army's principal medical training facility, Camp Grant educated medical trainees in its extensive Medical Department Replacement Center at the rate of 10,000 a month at the war's height, graduating nearly 100,000 Army medical personnel over the course of the war. With Medical Department Replacement Center trainees getting acquainted with Army life in the field, mess kitchen staff prepare to cook "slum" for hungry medical trainees in their Camp Grant field kitchen. Visible in the background are the "pup tents" or "shelter-halves" used as accommodations during field exercises. (Photo: Rockford Photo Service)

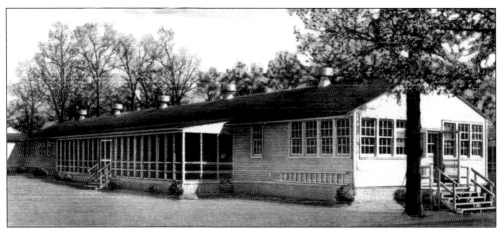

CAMP GRANT—HOSPITAL WARD. Operation of Camp Grant's 400-building, 1,500-acre Medical Department Replacement Center training facility by late 1943 included creation of the 1633rd Service Unit-Medical Replacement Training Center, which encompassed four massive 1,000-bed training general hospital units—the 61st, 101st, 102nd, and 103rd General Hospitals. Operation of each general hospital unit required a personnel roster including 500 enlisted men, 56 officers, 1 warrant officer, 100 nurses, 3 physical therapy aides, and 3 dieticians. The 1633rd trained medical soldiers for a variety of wartime medical units, including hospital trains, station hospitals, and field general hospitals.

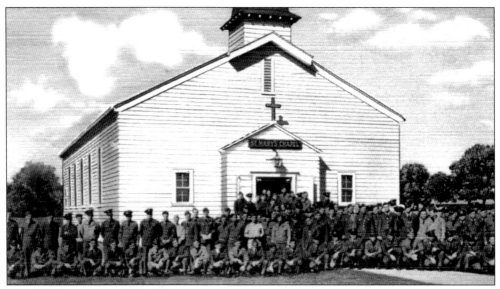

CAMP GRANT—ST. MARY'S CHAPEL. Following Camp Grant's 1946 closure after World War II, the War Assets Administration presided over the sale of Camp Grant's assets, including four wood-frame chapels that once served the religious needs of U.S. soldiers. Pictured is Camp Grant's Roman Catholic St. Mary's Chapel, along with some of the World War II soldiers who worshipped there. As late as 1944, 19 chaplains served Camp Grant. Sold for $1,075 each, three of the 37 x 81 ft., 400-seat chapels stayed in the Rockford area, serving as modest first homes for Rockford's Alpine Lutheran Church, Loves Park's Evangelical Free Church, and St. Bridget Catholic Church. The fourth Camp Grant chapel was sold to Chicago's Jewish Temple Menorah congregation. (Photo: Herzog Studio)

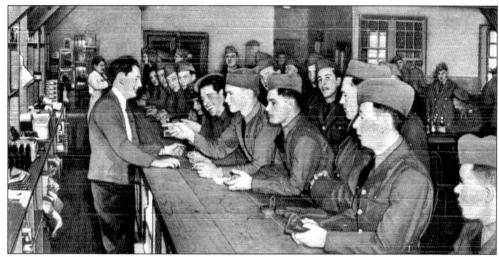

CAMP GRANT—POST EXCHANGE, 1942. One of the most popular stops at Camp Grant for servicemen was the busy Post Exchange or "PX." At the PX, soldiers could purchase a variety of discounted items, including snacks, soft drinks, cigarettes, magazines, and Camp Grant postcards. Writing with "Love & Kisses" to Donald H. Sowl at Great Lakes Naval Academy, "Babe" notes she'll soon be working in support of the nation's war effort at the Camp Grant PX in Rockford: "Dearest Darling - This is a picture of practically just what I'm going to do starting tomorrow. Gee, darling, I wish I was doing it for the Navy instead of the Army, but I can't very well. . . ."

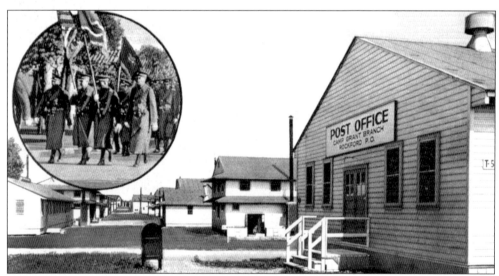

CAMP GRANT—U.S. POST OFFICE. Before satellite technology, cell phones, and computer e-mail, keeping in touch with family and friends back home during wartime meant traditional "snail mail" correspondence via letters and postcards. For U.S. Army soldiers stationed at or just passing through Camp Grant, the Rockford post office's "Camp Grant Branch" provided a popular and invaluable service. Following the end of the war, much of the expansive 3,280-acre camp was sold and redeveloped beginning in 1946 for a variety of residential, commercial, industrial, and recreational uses. The War Assets Administration gave nearly 1,200 acres to the Greater Rockford Airport Authority for its planned Greater Rockford Airport.

Ten

PARKS, RECREATION, AND TOURISM

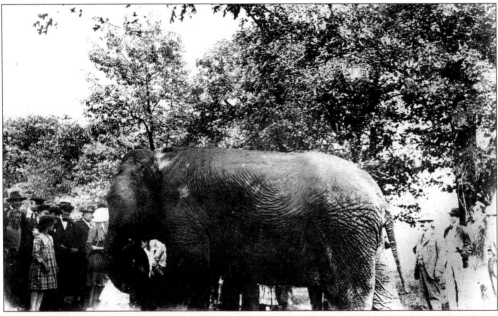

"BABE AND ADMIRERS—BLACK HAWK PARK ZOO," 101 FIFTEENTH AVENUE. The short-lived Rockford Zoological Society operated a small, but popular zoo at riverfront Blackhawk Park from 1919 to 1921. Featured attractions included a Bengal tiger, a buffalo, several monkeys, and numerous small animals. The zoo's headlining attraction was "Big Babe," a popular female elephant donated by the Ringling Brothers Circus. While Babe's addition delighted zoo-goers, it quickly worried zoo officials who discovered that the pachyderm's voracious appetite ate up the zoo's budget—and then some. In 1921, the Rockford Park District turned down the Zoological Society's request for additional funding to finance Babe's appetite. The zoo subsequently closed and Babe, wrote former *Rockford Register Star* editorial page editor Chad Brooks, "presumably...went on eating to its heart's content at someone else's expense." Plans are currently underway for development of the 180-acre not-for-profit World Wildlife Kingdom zoo and entertainment complex in suburban Cherry Valley. (Courtesy: Lewis Moore)

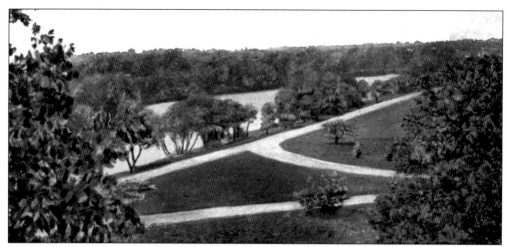

SCENE IN BLACKHAWK PARK AND ROCK RIVER, 101 FIFTEENTH AVENUE, 1930. Looking northwest toward the Rock River and Fifteenth Avenue from wooded bluffs overlooking Blackhawk Park's low-lying 3,175-foot waterfront, one sees the scenic drives and river views that have made the 91-acre Rockford Park District facility a favorite recreation destination since 1911. A center for Rockford baseball, Blackhawk Park is today best known for 4,300-seat Louis F. Marinelli Field (*c.* 1988), home to Rockford's Midwest League Class-A Expos, Royals, Cubs, and Reds franchises between 1988 and 1999, and the Frontier League Rockford Riverhawks since 2002. In 2005, the Riverhawks will relocate to a new $7 million 3,500-seat stadium near I-90 and East Riverside Boulevard in suburban Loves Park.

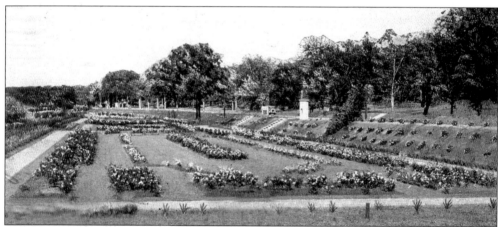

SUNKEN GARDENS—SINNISSIPPI PARK, 1401 NORTH SECOND STREET, 1928. Developed beginning in 1909 as the Rockford Park District's founding large-scale park development, signature 123-acre Sinnissippi Park remains a premier recreational destination. While hillside portions of Sinnissippi Park were developed between 1909 and 1917, it wouldn't be until 1922 that development began on the park's expansive, low-lying riverfront. Some 10,000 cubic feet of soil were excavated to create landscape architect Clarence Pedlow's popular sunken gardens, seen here. Other early riverfront developments included a lagoon, rose and perennial gardens, pathways, terraces, and gazebos. Contemporary riverfront developments include the 10.1-mile, *c.* 1976 Rock River Recreation Path and the addition of large-scale public art—Milwaukee artist Terese Agnew's *c.* 1988 *Rockmen Guardians,* Rockford sculptor Gene Horvath's *c.* 1974 *Sinnissippi Crab,* and internationally-famed artist Alexander Liberman's *c.* 1978 *Symbol.*

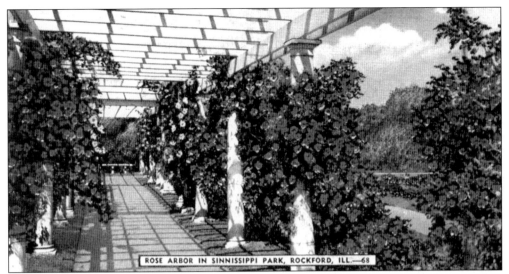

ROSE ARBOR—SINNISSIPPI PARK, 1401 NORTH SECOND STREET, 1940. A longstanding signature feature of Sinnissippi Park's popular Sinnissippi Gardens is its fragrant and colorful Rose Garden. Developed in a once-swampy section of Sinnissippi Park known as Blue Man's Pond, the Rose Garden quickly became one of the park's most popular features. In decline from the 1950s into early the 1980s, Sinnissippi's Rose Garden eventually lost its prestigious American Rose Society accreditation. In 1983–84, the Men's Garden Club of Rockford redeveloped the Rose Garden, planting 4,000 bushes representing some 100 rose varieties. Atwood Vacuum Machine Company's $25,000 donation of a centerpiece 32-foot floral clock further enhanced the restoration, which saw the gardens regain their accreditation.

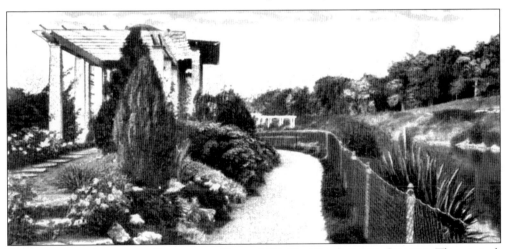

PERGOLA AND LAGOON—SINNISSIPPI PARK, 1401 NORTH SECOND STREET. The genteel, timeless qualities of Sinnissippi Park's lagoon and shady *c.* 1916 pergola remain an enduringly familiar and popular destination, particularly as a backdrop for wedding pictures. The Sinnissippi Park lagoon, developed in 1922 from a natural pond known as Red Man's Pond, was originally stocked with waterfowl donated by Rockfordian Will O. Doolittle, later editor of *Parks & Recreation* magazine. Long popular with kids of all ages, the lagoon is today home to waterfowl including ducks, geese, and stately mute swans. In winter months, the frozen lagoon is a popular venue for free public outdoor ice skating. (Courtesy: Mary Lou Liebich Yankaitis)

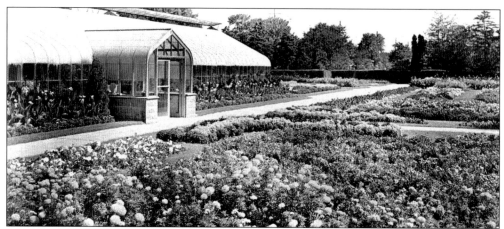

GREENHOUSE AND GARDENS—SINNISSIPPI PARK, 1401 NORTH SECOND STREET. The Sinnissippi Park greenhouse has been a popular attraction since the Rockford Park District's first conservatory was constructed in 1914. Built in 1959, the Rockford Park District's current $59,000 greenhouse and aviary facility is open year-round, showcasing a variety of changing floral displays. The annual fall Chrysanthemum Show, featuring 4,000 brilliantly-colored mums, has been a community staple since 1927. The park's outdoor Sinnissippi Gardens include the annual garden seen here, home to thousands of colorful bedding plants, in addition to shady perennial gardens, a dramatic *c.* 1984 floral clock and the popular All-American Rose Selection-accredited Rose Garden. (Photo: Henry Brueckner)

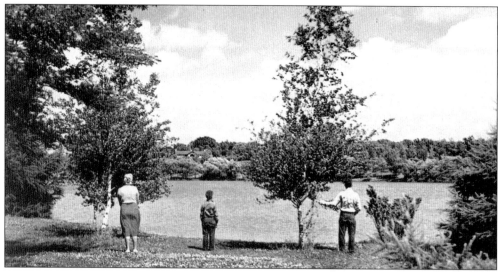

LEVINGS PARK, SOUTH PIERPONT AND SOUTH JOHNSTON AVENUES. Located on the former southwest Rockford farm of Rockford Township highway commissioner Thomas G. Levings, 123-acre Levings Park was deeded to the Rockford Park District in 1920. Created by damming Kent Creek, 35-acre Levings Lake was developed in 1932 by a 175-man Depression-era Works Project Administration work crew. One of the park district's early anchor park developments, Levings Park underwent an extensive $1.1 million redevelopment in 1988–90. Today, Levings Park offers baseball, basketball, tennis, picnic and playground facilities, and paddleboat rentals, among other amenities. Levings Lake's sandy Standfield Beach is a popular swimming destination. (Photo: Jack Taylor)

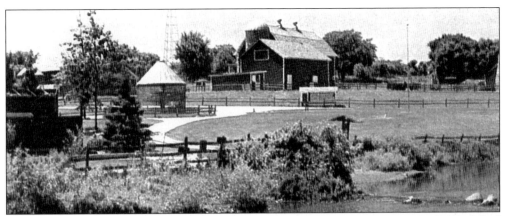

CHILDREN'S FARM, 5209 SAFFORD ROAD. Located in 115-acre Lockwood Park, the Rockford Park District's Children's Farm offers city kids an up-close-and-personal encounter with horses, ponies, sheep, chickens, goats, pigs, and peacocks. Lockwood Park, a beautiful rural setting of hills, meadows, and woodlands, also houses the Trailside Equestrian Center and Lockwood Park Observatory. Operating nearly 190 park, trail, golf, ice skating, and museum facilities, the Rockford Park District earned "National Gold Medal for Excellence in Parks & Recreation Management" honors from the National Recreation and Park Association in 1989 and 1995. Rockford Park District facilities log nearly 11 million user visits annually. (Photo: Eldon Glick; Courtesy: Mary Lou Liebich Yankaitis)

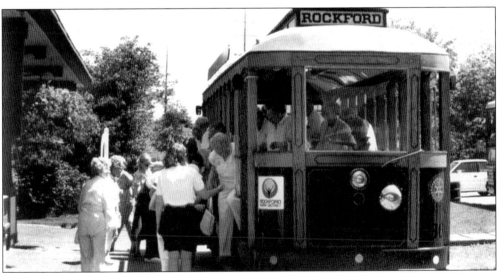

TROLLEY CAR 36, 302 NORTH MADISON STREET. In 1982, the Rockford Rotary Club donated $47,500 to the Rockford Park District to commission this 45-passenger replica of an open-air Rockford and Interurban Railway Co. (1880–1936) trolley car. Concurrently, Rockford Township donated $165,000 to build period station and trolley barn facilities at downtown's Riverview Park, developed on the old city yards site in 1973–75. A popular summertime entertainment attraction, Trolley Car 36 runs a two-mile route on Union Pacific right-of-way between downtown Rockford and Sinnissippi Park. Interesting highlights of the 45-minute tours include riverfront Sinnissippi Park, Alexander Liberman's famed *Symbol* sculpture, the Rock River YMCA, the Rockford Brewing Co. brewery, and a North Madison Street ride on one of the nation's few remaining railroad "road runs."

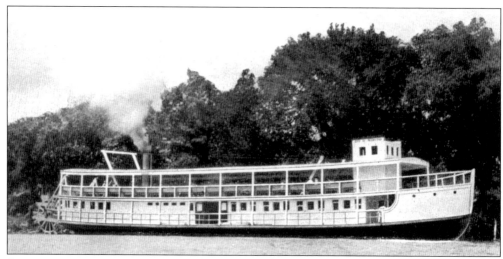

STEAMER *CITY OF ROCKFORD* ON THE BEAUTIFUL ROCK RIVER. Commissioned in 1900 by Rockford entrepreneurs Amasa Hutchins and John T. Buker, the popular sternwheel passenger excursion steamer *Illinois* received an extensive *c.* 1918 lake-style makeover by new owner Excursion Amusement Co. as the rechristened *City of Rockford*. Carrying some 50,000 passengers annually, the popular *City of Rockford* was destroyed in a February 1924 arson blaze billed by the Rockford *Morning Star* as "one of the most spectacular seen in Rockford." Extensively damaged far beyond its insurance coverage, the *City of Rockford* was towed far into the Rock off its winter St. Clair Street (Y-Boulevard) mooring and sunk, ending the city's 70-year commercial steamboat history.

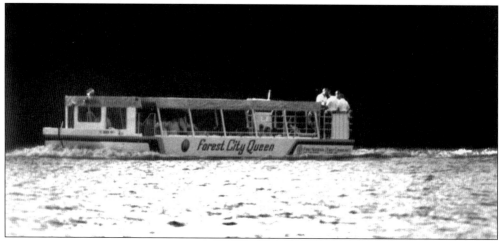

FOREST CITY QUEEN, **324 NORTH MADISON STREET.** Commercial passenger boating on the Rock River revived in 1979 when Bank One Rockford forerunners First National Bank and North Towne National Bank donated $47,000 to the Rockford Park District to purchase and operate the 49-passenger *Forest City Queen*. Docked at Riverview Park and constructed by LaCrosse, Wisconsin-based Mattie River Yachts, the $25,964 *Forest City Queen* operates 45-minute round-trip warm weather cruises between downtown Rockford and suburban Loves Park's Shorewood Park, home of the nationally-ranked Rockford Ski Broncs (*c.* 1966) water-ski show team. The narrated tour includes the history of Rockford, the Rock River, Sinnissippi Park, and the many stately homes lining the riverfront.

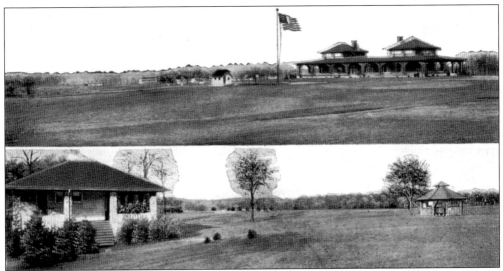

INGERSOLL GOLF CLUB HOUSE, 101 DAISYFIELD ROAD/SINNISSIPPI GOLF CLUB HOUSE, 1300 NORTH SECOND STREET. As late as the early 1910s, golf in Rockford, like the game across the United States, was largely the province of the wealthy—equipment was costly, public courses were few or non-existent, and pioneering private golf clubs like the *c.* 1899 Rockford Country Club were expensive and exclusive. Golf mainstreamed in Rockford with the Rockford Park District's 1912 development of its pioneering public Sinnissippi Golf Course at Sinnissippi Park (bottom). Golf's explosive popularity in the 1920s and early 1930s spurred the development of additional early park district golf course facilities—Lt. Clayton Ingersoll Memorial Golf Course (top) in 1922 and Sandy Hollow Golf Course in 1930. (Courtesy: Mark D. Fry)

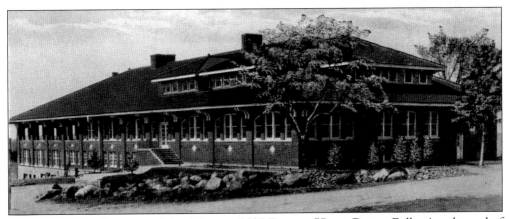

HARLEM HILLS COUNTRY CLUB HOUSE, 5135 FOREST HILLS ROAD. Following the end of World War I, 40 members of South Main Street's Motor Heights Golf Club subscribed $2,000 to create Harlem Hills Country Club, purchasing the gently rolling Joel Johnson farm just north of Rockford on Illinois 173. Architect Gilbert Johnson's $58,000 clubhouse, seen here, was built in 1924–25 on the site of the old Johnson barn. Hard hit by the Great Depression, Harlem Hills was lost to bond holders in 1933. In 1934, the club was reborn under new directors as today's Forest Hills Country Club. Since 1996, the charitable annual Rockford Pro-Am Golf Tournament (*c.* 1977) has been hosted by Forest Hills. (Courtesy: Midway Village & Museum Center)

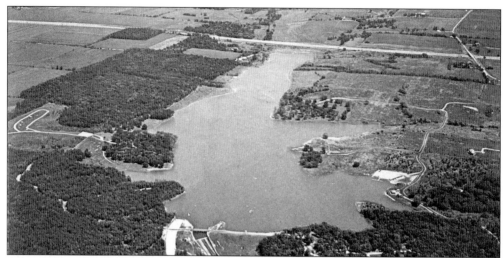

Pierce Lake and Rock Cut State Park, 7318 Harlem Road. A former Potawatomi Indian hunting ground, this 700-acre tract of meadows and timberlands comprising the Illinois Department of Conservation's Rock Cut State Park was developed in 1955–62. Located in suburban Loves Park, Rock Cut is anchored by 162-acre Pierce Lake, created by the damming of Willow Creek and named in honor of State Representative William Pierce (D-Rockford), who championed the park's development. Today encompassing 3,092 acres, Rock Cut State Park offers a variety of warm weather activities including fishing, sailing, swimming, camping, picnicking, hiking, and horseback riding. During winter months, Rock Cut is a popular cross-country skiing and snowmobiling destination. (Photo: Carlson Commercial Photographs)

Tinker Swiss Cottage, 411 Kent Street. The legacy of few men has loomed larger in Rockford history than that of Hawaiian-born Robert Hall Tinker (1836–1924), a prominent early business, political, and community leader. Heading Rockford's industry-building Water Power District and Chicago, Rockford & Northern Railroad, Tinker would serve as the city's "boy mayor" in 1875 at age 39. And, in 1909, he helped found the Rockford Park District. But perhaps Tinker's most lasting legacy is his 20-room bluff-top *c.* 1865 "Swiss Cottage" overlooking the city's 1834 birthplace from a 5.5-acre site along Kent Creek. The National Register-listed residence, a historic preservation, was deeded to the park district upon Tinker's death. The Swiss Cottage opened to the public as a museum in 1943 following the 1942 death of Tinker's second wife, Jessie Dorr (Hurd) Tinker.

LIBRARY, TINKER SWISS COTTAGE. Robert Tinker's two-story Gothic library was inspired by his 1860s visit to the home library of Scottish novelist Sir Walter Scott. Tinker's library is famed for its exquisite woodworking, as illustrated by its unique spiral staircase, a structural marvel reported to have been steamed and shaped over several years from a single piece of walnut wood. The sumptuous woodworking in Tinker's library, which holds hundreds of rare antique books, encompasses numerous woods including cherry, oak, cedar, pine, and butternut. The sofa (center) was used by President Abraham Lincoln, then a Springfield lawyer, during an 1855 visit as legal counsel for Rockford agricultural implement manufacturer John H. Manny in a patent infringement case filed by rival reaper manufacturer Cyrus McCormick. In 1870, Tinker married Manny's widow, Mary Dorr Manny, bringing the famed "Lincoln Sofa" into the Tinker family fold. (Photo: Henry Brueckner)

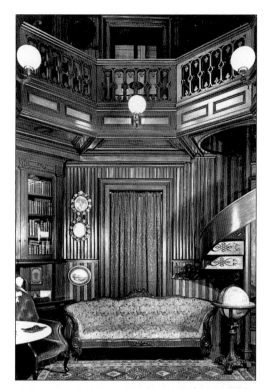

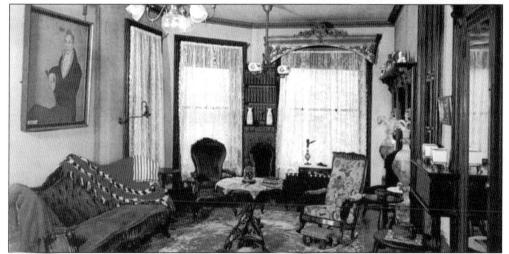

LIVING ROOM, TINKER SWISS COTTAGE. Tinker Swiss Cottage's Victorian-styled living room reflects interior decorating styles prevalent in the Midwest in the 1840s. Living room furnishings include two carved alabaster pedestals from Italy, hand-carved Victorian furniture, and several early American "primitive" oil paintings, including two 1814–1816 primitive-styled portraits of the grandmother and uncle of Mary Dorr Manny, who became Tinker's wife in 1870. The rocker was used by future president Abraham Lincoln during an 1855 visit to the nearby South Main Street mansion of Rockford industrialist John H. Manny. A longtime bachelor, Tinker married Manny's widow, Mary Dorr Manny, in 1870 at age 44. The Tinkers quickly became one of Rockford's most influential couples. (Photo: Henry Brueckner)

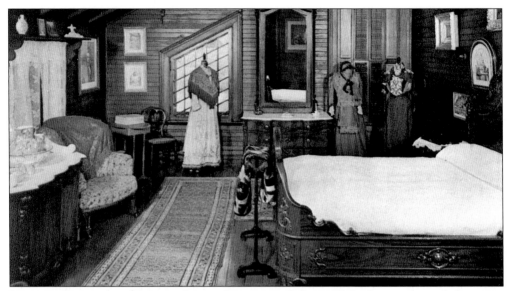

MASTER BEDROOM, TINKER SWISS COTTAGE. Robert Tinker's wood-paneled master bedroom, with its beamed ceiling, is the most Swiss-styled interior room in his famed *c.* 1865 residence, dubbed "Tinker's Swiss Cottage" for its Swiss chalet-styled exterior architecture. Among the master bedroom features showcased on this postcard are Tinker's exquisite hand-carved rosewood bedroom furnishings, marble-topped dressers and commodes, several of wife Mary Tinker's 1860s dresses, an 1816 family Bible, and a colorful English spode "bedroom china" commode set. (Photo: Henry Brueckner)

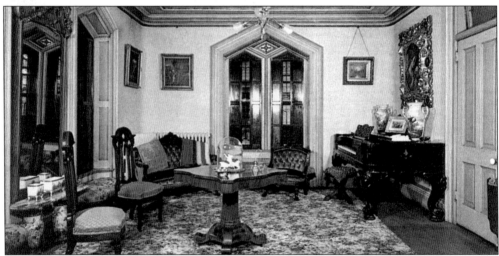

PARLOR, TINKER SWISS COTTAGE. Outside of the home's exterior and master bedroom, there was little else Swiss about Robert Tinker's "Swiss Cottage," as evidenced by his lavishly appointed Victorian living room, decorated in the popular style of the 1870s to 1890s. Among the Tinker family furnishings pictured here are an early *c.* 1850 square rosewood Steinway grand piano, 17th century Italian oil paintings, diamond dust mirrors, and French porcelain vases. The chairs, piano stool, benches, "gents chairs," and sofa retain their original 19th century upholstery. The parlor's Victorian fireplace is made of Vermont marble and decorated at the sides with French bronze figurines. (Photo: Henry Brueckner)

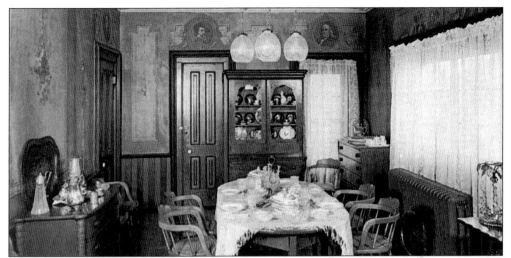

DINING ROOM, TINKER SWISS COTTAGE. Though plainly decorated by comparison to the lavish Gothic and Victorian decoration in many of Tinker Swiss Cottage's other rooms, Robert Tinker's dining room nevertheless offers its own decorative delights. Of particular note are the distinctive wall murals of fruits, vegetables, birds, and scenic views, topped by a below-the-ceiling border featuring portrait busts of famous statesmen, poets, and authors, including Benjamin Franklin. The flooring is of butternut, mahogany, and black oak. Notable dining room furnishings include the Tinker family's heirloom silverware and rare German "Dresden" china. (Photo: Henry Brueckner)

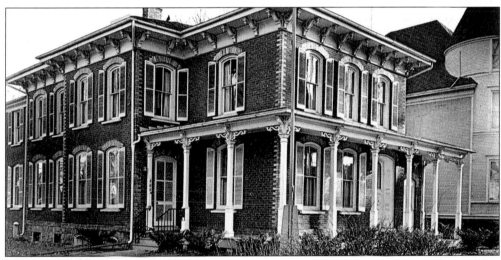

ERLANDER HOME MUSEUM, 404 SOUTH THIRD STREET. Beginning in 1852, a massive influx of Swedish immigrants built Rockford into one of the largest ethnic Swedish communities in the nation. Built in 1871 by early immigrant Swedish businessman John Erlander (1826–1917), the 12-room Italianate-styled Erlander Home was sold to the Swedish Historical Society of Rockford in 1952 for conversion into a museum. Dedicated by Swedish Prime Minister Tage Erlander, the museum houses a fine collection of Rockford-made products including Union, Central, and Excelsior furniture and a piano and dulcette manufactured by C.A. Haddorff Piano. The museum, a Rockford historic landmark, is located in the heart of downtown's National Register-listed Haight Village Historic District. (Photo: Henry Brueckner)

GRAHAM-GINESTRA HOUSE, 1115 SOUTH MAIN STREET. The first local landmark of the *c.* 1978 Rockford Historic Preservation Commission, the transitional Italianate/Greek Revival-styled Graham-Ginestra House was added to the prestigious National Register in 1979. Constructed of native Illinois dolomite limestone, the *c.* 1857 home was built by Connecticut native Freeman Graham (1806–96). Relocated to Rockford in 1856, Graham and his sons operated Rockford's *c.* 1865 Graham & Co. Cotton Mills and Graham Bros. Distillery (1876–1915), Illinois's first sour mash whiskey distillery. The home remained in the Graham family until its 1926 sale to Italian-Americans Leonard and Mary Ginestra. In 1978, daughter Therese Ginestra-Schmeltzer established the non-profit Graham-Ginestra House, Inc. to maintain the house and its landscaped garden grounds as a museum and historic landmark. (Courtesy: Graham-Ginestra House, Inc.)

THE TIME MUSEUM, 7801 EAST STATE STREET. Rockford businessman Seth G. Atwood's Time Museum (1970–99) was an internationally-renowned tourist destination. Housing the world's finest and most comprehensive horology (timekeeping) collection, the 10,000-square-foot Time Museum, housed in the Atwood family's Clock Tower Resort, was featured on the History Channel and PBS's *Smithsonian World.* Atwood spent four decades amassing his 1,600-piece collection of original timepieces and painstakingly detailed reproductions. The family's 1999 sale of Clock Tower Resort forced Atwood's closure of the popular museum. While Atwood retained a few prized timepieces, the collection was sold at New York's famed Sotheby's Auction House in 1999, 2002, and 2004. Between 2001 and 2004, a large portion of the collection was displayed at the Museum of Science and Industry's short-lived National Time Museum of Chicago.

MIDWAY VILLAGE STREET SCENE, MIDWAY VILLAGE & MUSEUM CENTER, 6799 GUILFORD ROAD. Founded cooperatively in 1971 by the Harlem, Rockford, and Swedish Historical Societies, the Rockford Museum Center's embryonic History Gallery opened in 1974 on a 6.5-acre east side site donated by Carl Severin. The outdoor Midway Village museum, pictured here, opened in 1975 with four buildings. The Rockford Museum Center, later renamed Midway Village & Museum Center, has grown considerably, increasing its campus to 137 acres and adding museum galleries in 1977, 1985, and 1986. The 53,000-square-foot local history museum encompasses an 80,000-object archive, including a permanent exhibit dedicated to women's baseball's famed Rockford Peaches (1943–54). The Midway Village outdoor museum, meanwhile, has grown into a 24-building complex encompassing a mix of authentic and reconstructed 19th and early 20th century buildings. (Photo: Jon McGinty Photography)

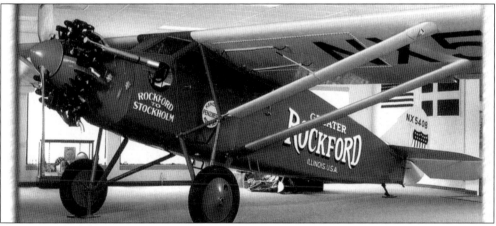

GREATER ROCKFORD, **MIDWAY VILLAGE & MUSEUM CENTER, 6799 GUILFORD ROAD.** In 1986, Midway Village & Museum Center added its Hassell Aviation Gallery to house the restored *c.* 1928 Stinson Detroiter *Greater Rockford* (NX5408). Piloted by Col. Bert R.J. "Fish" Hassell (1914–74) and navigator Parker Dresser "Shorty" Cramer (1896–1931) on their ill-fated August 1928 Rockford-Stockholm trans-Atlantic Arctic Circle flight, the *Greater Rockford* made an emergency landing on a Greenland glacier, where the plane remained until its 1968 recovery. Despite failing to reach Sweden, the flight nevertheless proved a success for Hassell, who championed his North America-Europe "Great Circle Route" commercial Arctic Circle air route. Establishment of the enduring Great Circle Route would serve as the springboard for Hassell's distinguished military aviation career. (Photo: Jon McGinty Photography)

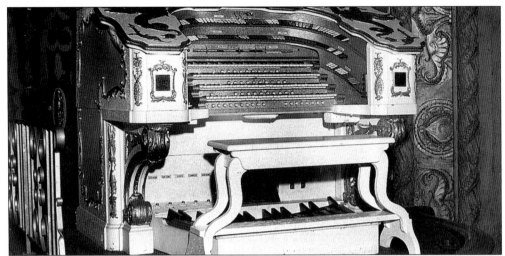

CORONADO THEATRE 4-17 BARTON ORGAN, 314 NORTH MAIN STREET. Celebrated as "Rockford's Wonder Theater," Peoria architect Frederick J. Klein's 2,440-seat, $1.5 million Coronado Theater (*c.* 1927) is one of the nation's finest surviving 1920s-era movie and vaudeville palaces. Pictured is the Coronado's $50,000, 4-manual, 17-rank *c.* 1927 Grande Barton "4-17" Theatre Pipe Organ. The magnificent 1,229-pipe Barton was a Coronado mainstay in its early years, when entertainment included vaudeville shows, musical performances, and silent films. The Grande Barton, long silent and in disrepair, was later restored by the *c.* 1973 Land of Lincoln Theatre Organ Society (LOLTOS). Dropping movies in 1984, the Coronado continues its live stage tradition, hosting local performing arts engagements, LOLTOS concerts, and traveling national concerts and stage shows. (Photo: Dave Lombardo)

INTERIOR DETAILING, CORONADO THEATER, 314 NORTH MAIN STREET. Willard N. Van Matre's *c.* 1927 Coronado operated as a dual use "atmospheric" movie and Publix Circuit vaudeville palace. The lavishly decorated "Entertainment Baroque" Coronado contains a mélange of Spanish, Venetian, French, and Moorish design elements. Coronado headliners have included ventriloquist Edgar Bergen, silver screen cowboy Tom Mix, singer Bing Crosby, the Marx Brothers comedy team, stripper Gypsy Rose Lee, presidential hopefuls John F. Kennedy and Ronald Reagan, jazz great Louis Armstrong, comic pianist Liberace, magician David Copperfield, classical violinist Itzhak Perlman, and comedians Bob Hope, Jack Benny, Milton Berle, and Jay Leno. Home to motion pictures from 1927–84, the Coronado debuted Rockford's "talkie" era in 1928 with *The Jazz Singer.* Springfield-based Kerasotes Theatre Co. donated the National Register-listed Coronado to the City of Rockford in 1997. In 1999–2001, the Coronado underwent an $18.5 million public/private-funded renovation and expansion into a 2,295-seat performing arts center managed by the city's MetroCentre Authority. (Photo: Bryn Carter)

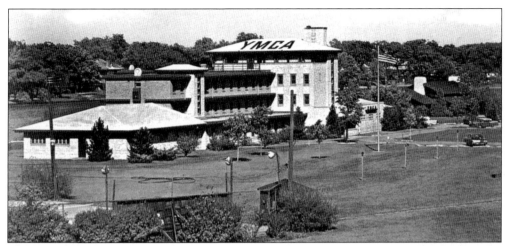

YMCA Resident and Administration Building, 200 Y Boulevard (St. Clair Street). Heading into World War II, 84,687-resident Rockford was the nation's second-largest city without a YMCA. The Rockford YMCA, a city presence from 1858 to 1862 and 1876 to 1906, was re-established in 1941 with a $148,000 bequest from Swedish immigrant Pehr August "P.A." Peterson, a prominent Rockford industrialist, philanthropist, and venture capitalist. In 1952, Rockford's fledgling YMCA built this $704,000, 95-bed Prairie-styled residence and administration building on an 11.3-acre riverfront site acquired from Barber-Colman Co. president Howard Colman. In a controversial decision, the Rockford YMCA suspended its transient housing outreach in 1990, razing this structure in 1994. (Photo: Henry Brueckner)

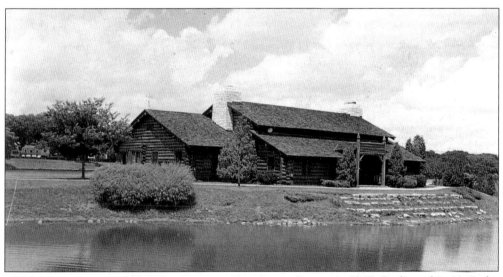

YMCA Log Lodge, 200 Y Boulevard (St. Clair Street), 1967. Dedicated in 1947, the Rockford YMCA's $45,000 "Log Lodge" was hand-built by six Hayward, Wisconsin lumberjacks on its picturesque 11-acre riverfront campus at North Madison and St. Clair Streets, renamed Y Boulevard in 1950. Built by traditional methods using no nails, the Log Lodge was constructed with hand hewn-and-notched white pine and hemlock logs. The man-made pond in front of the Log Lodge was later added as an aesthetic complement to the rustic lodge setting. Built on the site of the old riverfront Knickerbocker Ice House, the popular Log Lodge offers program, meeting, and banquet facilities. (Photo: Henry Brueckner)

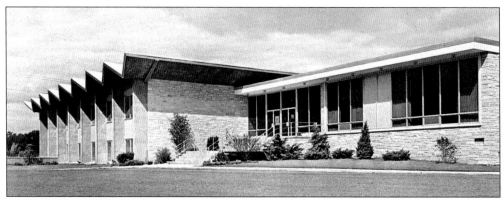

YMCA I.D. PENNOCK PHYSICAL EDUCATION CENTER, 200 Y BOULEVARD (ST. CLAIR STREET). Named in honor of founding Rockford YMCA general secretary I.D. Pennock (1941–67), the $1.1 million, 55,000-square-foot I.D. Pennock Physical Education Center opened in 1964, featuring an indoor/outdoor pool, indoor golf and archery ranges, squash and handball courts, and a main and auxiliary gymnasium. Sizeable expansions were made in 1977–79 and 1985, adding an indoor running track and expanded basketball, volleyball, handball, racquetball, and aquatic facilities. In 1995, the YMCA undertook a $3 million renovation and expansion of its flagship I.D. Pennock facility. The 16,000-member Rockford YMCA, the nation's largest single-facility YMCA, reorganized in 2000 as YMCA of the Rock River Valley. (Photo: Henry Brueckner)

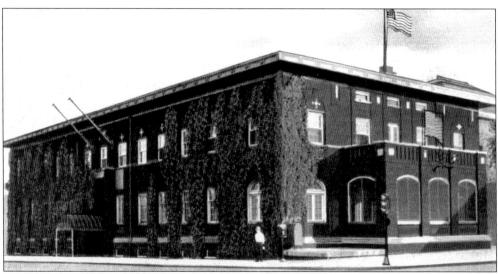

ELKS LODGE, 210 WEST JEFFERSON STREET. Organized in 1901, Elks Lodge No. 64 included many Rockford elites—textile magnate William Nelson, Civil War veteran Colonel Thomas G. Lawler, mail order seedsman Roland H. Shumway, judge R.K. Welsh, banker Chandler Starr, and leading downtown retailers including pharmacist Hosmer C. Porter, cigar dealer F.H. Moffatt, crockery and china merchant A.W. Wheelock, and clothiers David Turkenkoph and Christian F. Henry. In 1912–13, Rockford's Elks built this $105,000 downtown lodge. Peaking at over 1,300 members in the 1960s, membership declined to 262 by 1990, when the aging lodge building was sold to a group of local developers. Now owned by Rockford's nonprofit Abilities Center, downtown Rockford boosters are exploring redevelopment scenarios for the long-vacant lodge, a city historic landmark.

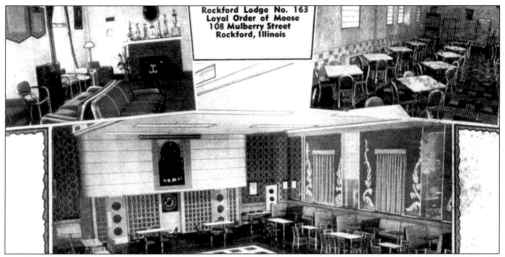

ROCKFORD MOOSE LODGE, 108-110 MULBERRY STREET. Organized in 1909, Rockford Lodge No. 163 of the Illinois-based Loyal Order of Moose built itself into one of the nation's largest Moose lodges by the mid-1970s, years when its membership peaked at over 5,000. Originally meeting in the C.F. Henry Block, 122 North Wyman, Rockford's Moose built this longtime downtown lodge in 1916. Forced out of its lodge in 1975 by downtown urban renewal and the eventual construction of the Luther Center senior high-rise, Moose Lodge 163 relocated to a newly-constructed lodge facility along Illinois 2 on the city's far northwest side. (Courtesy: Mark D. Fry)

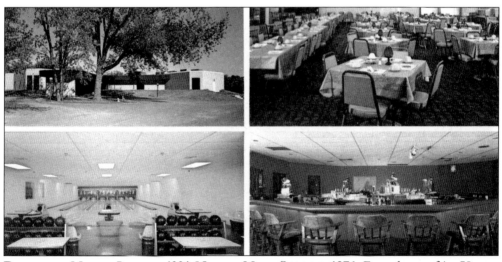

ROCKFORD MOOSE LODGE, 4301 NORTH MAIN STREET, 1976. Forced out of its 59-year downtown lodge by urban renewal in 1975, Rockford Moose Lodge No. 163 built this 18,000-square-foot facility on a wooded 16-acre riverfront site on the city's far northwest side. Among the new lodge facilities pictured are the club's popular circular bar, six-lane bowling alley, and spacious banquet room, which boasted one of the area's largest dance floors. Like other fraternal service lodges in Rockford and across the nation, Rockford's Moose suffered steep membership declines in recent decades. From its nation-leading peak, Lodge No. 163 membership fell from 5,000 in the mid-1970s to just 1,500 by 1999, when the Moose sold this lodge and moved to rented quarters.

TEBALA SHRINE TEMPLE, 323 NORTH MAIN STREET. Chartered in 1894 and named for a desert oasis between Damascus and Aledo, Rockford's Tebala Shriners built this $145,000 Masonic Temple in 1914–16 on the southeast corner of North Main Street and Park Avenue near Beattie Park (left). Designed by Rockford architect Charles W. Bradley, Tebala Temple housed the "biggest little Shrine Temple in North America" until 1973. Oft used as a de facto civic auditorium in pre-MetroCentre days, notable headliners included wrestler "Gorgeous George," revivalist preacher Aimee Semple McPherson, humorist Will Rogers, silver screen singer Nelson Eddy, and waltz band leader Wayne King. Later occupied by Illinois Bell, the building was sold to Rockford-based PioneerLife in 1985 and razed for a *c.* 1986 parking deck. (Photo: Jack Taylor)

Ing Skating Palace
115 N. Second St.
ROCKFORD, ILLINOIS

ING SKATING PALACE, 115 NORTH SECOND STREET. In the skate-crazed 1940s and 1950s, roller-skating was a year-round six-day-a-week mainstay at downtown's Ing Skating Palace, which featured this 72 x 128 ft. main rink. One of Rockford's oldest and longest-lived entertainment venues, Wybe J. Van der Meer's enduring "Ball Room Beautiful" *Inglaterra* made its 1918 debut as a dime-a-dance hall feted as "Rockford's Aragon." Between the World Wars, thousands flocked to the Ing to dance to swinging "Big Bands" led by notables like Lawrence Welk and Jimmy Dorsey. By 1940, a national roller-skating craze drove the facility's conversion into the Ing Skating Palace. While roller-skating has long been the Ing's mainstay, the hall's roots in dancing have made a comeback in recent decades.

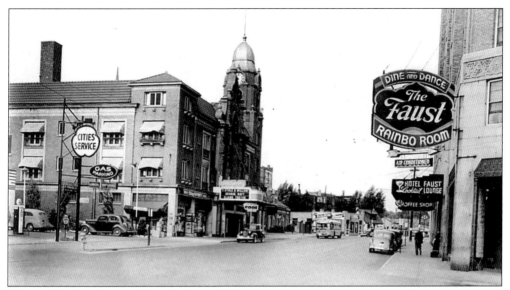

EAST STATE STREET ENTERTAINMENT DISTRICT, 1939. With the 1930 debut of the grand dame $2.75 million Hotel Faust (right), East State Street solidified its stature as one of Rockford's premier entertainment districts. The Faust, with its popular cocktail lounge, restaurants, and Art Deco-themed "Dine-and-Dance" Rainbo Room, was a busy East State entertainment anchor alongside the nearby *c.* 1918 Midway Theater (left), built by Chicago's Ascher Brothers theater chain as the Midwest's largest theater. Showing at the enduring National Register-listed Midway is Universal's *I Stole a Million*, a black and white crime film starring George Raft and Clair Trevor.

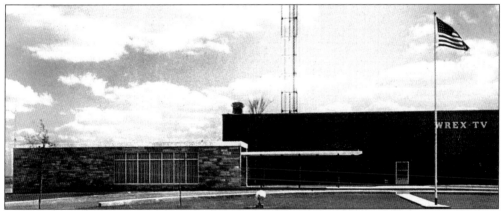

WREX TELEVISION CENTER, 10322 AUBURN ROAD. Rockford television debuted on May 4, 1953, when NBC-affiliated WTVO-39, now Channel 17, began broadcasting as one of the nation's first dozen UHF stations and Illinois's seventh TV station, the third built outside Chicago. Competitor Greater Rockford Television's WREX-13 began broadcasting on September 30, 1953, from this 12,000-square-foot "Television Center." Rockford's second television station and Illinois's eleventh, WREX-13 broadcast selected programs from ABC, CBS, and short-lived DuMont. Rockford's third station, WCEE, today's WIFR-23, began broadcasting as a CBS affiliate in September 1965, with WREX becoming an exclusive ABC affiliate. Rockford gained its first independent station, today's FOX-affiliated WQRF-39, in 1979. WREX and WTVO swapped network affiliations in 1995. (Photo: ES-N-LEN)

"UNCLE HAP"—WREX-TV. Before the advent and wide spread of syndicated television programming, low-budget locally-produced children's shows were a popular, economical time filler. Between 1953 and 1971, WREX-13 produced several children's shows—Harold "Hap" Gillaspy's western-themed *Uncle Hap and his Trail Tales*, WREX director Dick Christiansen's sci-fi oriented *Captain Nemo*, and Rod MacDonald's long-running *Roddy Mac*. Sponsored by Muller-Pinehurst Dairy, *Uncle Hap* ran weekday afternoons from 1953 to 1956, when the factory worker-turned-TV-cowboy headed west to capitalize on Hollywood's "Western" TV and movie craze. WREX competitors offered their own kiddie shows—WTVO with its five-year *Captain Bob and Melvin the Clown Show* in the 1950s and WCEE/WIFR-23 with its hugely popular *Mr. Mustache* from 1967 to 1981. (Courtesy: Mark D. Fry)

"RODDY MAC"—WREX-TV. Channel 13's popular Scot-hosted *Roddy Mac* (1953–71) reigned as Rockford's longest running locally-produced children's program. Hosted by longtime WREX production manager Rod MacDonald, the Monday-Friday show broadcast in various morning, mid-day, and afternoon time slots under several titles including *Luncheon with Roddy Mac* and the after-school *Roddy Mac's Comedy Clubhouse*. Over the years, MacDonald hosted a parade of well-known *Roddy Mac* guest stars including Sammy Davis, Jr., Carole Channing, Spike Jones, and William Bendix. By the time MacDonald hung up his timeworn red, tan, and yellow Tam-O'-Shanter cap, the community theater actor had logged over 4,000 half-hour shows for WREX. (Courtesy: Rod MacDonald)

CENTRAL PARK, 3100 AUBURN STREET. Complementing the ebullient, fun-loving Roaring Twenties mélange of flappers, jazz, and speakeasies, "traditional" amusement parks were in their "golden age." Wooden roller coasters, like this scream machine at Rockford's Central Park (1921–42), were immensely popular attractions. The Great Depression, World War II, and the entertainment options opened up by the automobile led to the quick demise of hundreds of traditional amusement parks like Rockford's Central Park, which was razed for more profitable commercial redevelopment. As U.S. amusement parks were closed and demolished, the number of classic American wooden roller coasters nose-dived from 2,000-plus in 1929 to just 245 by 1939. (Courtesy: Lewis Moore)

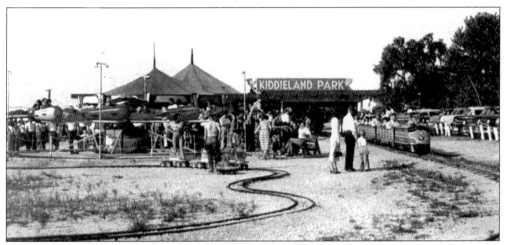

KIDDIELAND PARK, 5810 FOREST HILLS ROAD. Following the demise of Harlem Park (1890–1928) and Central Park, Kiddieland (1950–77) resurrected the amusement park era for lucky Rockford-area Baby Boomers and their Gen X children. Located adjacent to the old River Lane Outdoor Theater in suburban Loves Park, Kiddieland offered "fun for the whole family." Long operated by Milton W. Kling Sr., Kiddieland amusements included pony rides, chimps Koko and Tico, and numerous small-scale rides—a carousel, roller coaster, ferris wheel, rocket ride (left), the popular "Tubs of Fun," and the *Greater Rockford* (right), the "largest miniature train in the Middle West." Renamed Sherwood Park Kiddieland under the ownership of Kling's sons, the site was sold to neighboring American Chickle Co. and redeveloped. (Courtesy: Mark D. Fry)

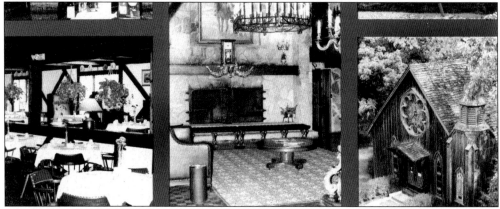

WAGON WHEEL RESORT, 600 BLACKHAWK BOULEVARD, ROCKTON, 1991. No attraction did more to put metro Rockford on the tourism map than the Wagon Wheel Resort (1944–1992) in historic 2,300-resident Rockton. Developed by Rockford Mobil distributor and service station operator Walt Williamson, the faux rustic Wagon Wheel grew into a prestigious 314-acre, 315-room resort with a six-month reservation list. Attracting regional elite from Milwaukee and Chicago, Wagon Wheel also drew Hollywood stars including comedian Bob Hope, silver screen "singing cowboy" Gene Autry, child star Shirley Temple, character actors George Peppard and James Arness, and actor-turned-president Ronald Reagan. After founder Williamson's 1975 death, Wagon Wheel steadily declined under a succession of owners, closing in 1992. Since 1993, the idled resort has been plagued by a string of arson fires. Almost 300 acres have been redeveloped with a golf course, offices, and residential housing.

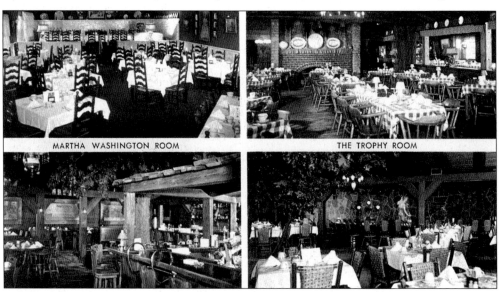

DINING ROOMS—WAGON WHEEL RESORT, ROCKTON, 1967. Showcased here are four of Wagon Wheel Lodge's most popular dining rooms in its 1950s, 1960s, and early 1970s heydays under founder Walt Williamson, who built the resort into one of the Midwest's most elite resorts. Pictured are the colonial-styled Martha Washington Room (top left), the Trophy Room (top right), the 1890s-styled Gay Nineties Room (bottom left), and the greenery-filled Garden Room (bottom right). Notes the pre-printed caption: "The enjoyable meals served in the quaint atmosphere of THE WAGON WHEEL will appeal to the most exacting appetite."

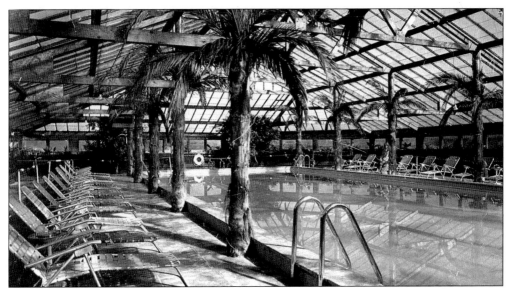

INDOOR SWIMMING POOL, WAGON WHEEL RESORT, ROCKTON. With its wide array of amenities, it was hard to be bored at Wagon Wheel Resort. In addition to this tropical-themed 25 x 60 ft. indoor pool, other popular amenities included horseback riding stables, an indoor ice skating rink, a 9-hole golf course, tennis courts, the Red Barn dinner theater, a 16-lane bowling alley and billiards room, upscale "Boardwalk" shops and salons, lavishly-decorated banquet halls, 4 popular restaurants, 12 taverns, a private airstrip, a ski chalet/accessory shop, and the posh members-only Key Club, which featured a massive wood bar from the 1904 St. Louis World's Fair. (Photo: Henry Brueckner)

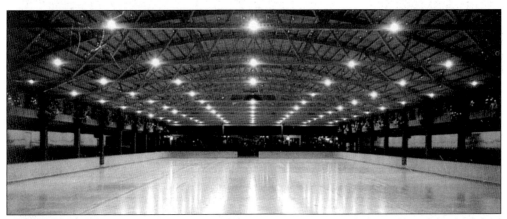

ICE PALACE—WAGON WHEEL RESORT, ROCKTON. Prior to the 1975 debut of the Rockford Park District's downtown Riverview Ice House, area ice skaters flocked north to the Ice Palace at Walt Williamson's Wagon Wheel Resort. The two-rink facility hosted the Wagon Wheel Cardinals semi-pro hockey team and a figure skating club that produced Rockford Olympic medallist Janet Lynn Nowicki. Nowicki trained for the 1968 and 1972 Winter Olympics at the Ice Palace at the behest of Williamson, who donated unlimited ice time and bankrolled her competition traveling expenses. A 1972 Olympic bronze medallist and five-time national champion regarded by many as the best freestyle figure skater in the business, *Newsweek* cover girl Nowicki joined the famed Ice Follies in 1973, becoming, at the time, the world's highest-paid professional female athlete. The Ice Palace closed in 1979. (Photo: Henry Brueckner)

To Pete God Bless you Janet Lynn may 1 2016

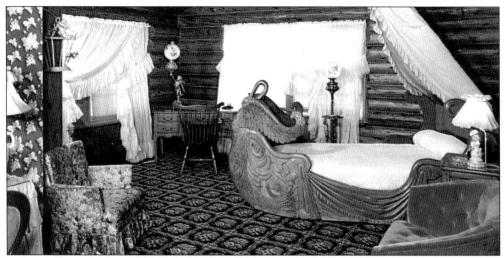

BRIDAL SUITE, WAGON WHEEL RESORT, ROCKTON. Room No. 39 at Walt Williamson's famed Wagon Wheel Resort was this Bridal Suite, one of three offered to honeymooning newlyweds. Furnishings included this 300-year-old hand-carved Swan Bed. At its height of popularity, the Wagon Wheel was a newlywed favorite, hosting over 300 weddings annually in Williamson's privately-owned, Gothic-styled *c.* 1964 Church by the Side of the Road. The enduring 247-seat non-denominational church, at 500 South Blackhawk Boulevard, outlived both Williamson and his once-elite resort. In the Wagon Wheel's heydays the church hosted 30,000 visitors annually. (Photo: Henry Brueckner)

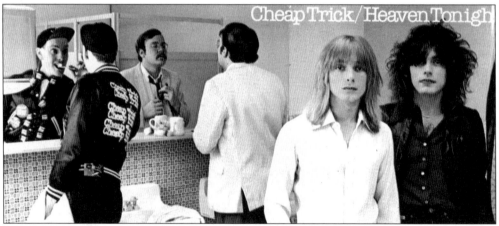

HEAVEN TONIGHT, **CHEAP TRICK, 1978.** This Epic Records promotional postcard features Rockford's leading American pop culture export—internationally popular Cheap Trick. Inspired by the "British Invasion," late 1960s Guilford High alums Rick Nielsen (left) and Tom Petersson (right) formed garage band Cheap Trick in 1973. In addition to lead guitarist/songwriter Nielsen and bass guitarist Petersson, the enduring band also includes drummer Bun E. (John) Carlos (center left) and vocalist Robin Zander (center right). A Midwest nightclub circuit sensation, Cheap Trick achieved national fame following Epic's 1978 release of their third album, *Heaven Tonight,* featuring the Top 100 hit single *Surrender.* Cheap Trick's impressive "power pop" accomplishments include four platinum and three gold albums, "Number One" single *The Flame,* and seven other Top 40 hits. Music critics predict Cheap Trick's enshrinement in the Rock and Roll Hall of Fame.